MANDALA WORLD
ADULT COLORING BOOK

ANCIENT AMERICA
BOOK 2

PRODUCED BY

Maya Necalli

&

Art Therapy Designs

Copyright © 2016 by Maya Necalli
All rights reserved.

Images may not be replicated or reproduced.

No part of this publication may be reproduced, transmitted or circulated in any form without permission in writing from the copyright owner.

ISBN: 1539397343
ISBN-13: 978-1539397342

Cover design by Art Therapy Designs.

First Edition: October 2016

INTRODUCTION

Art Therapy Designs presents unique theme-based mandala collections, beginning with the *Ancient America* series—illustrations inspired by the Aztec, Mayan, and Inca civilizations.

This coloring book contains **45** patterns presented as single-sided pages to help preserve each drawing.

The illustrations range from easy to medium-level difficulty.

Feel free to begin wherever you'd like!

Coloring is a form of art therapy, a creative calming technique that aids in de-stressing and relaxation for busy adults.

Our therapeutic activity book is designed for grownups but suitable for all advanced children and teens.

Enjoy!

NOTE: Cover mandala can be found near the beginning (8th design).

SPECIAL OFFERS

Visit our Facebook page to get free designs and find out when new coloring books are available!

Go to: www.facebook.com/ArtTherapyDesigns

You can also win freebies and keep up with new releases by joining our newsletter (see Facebook page).

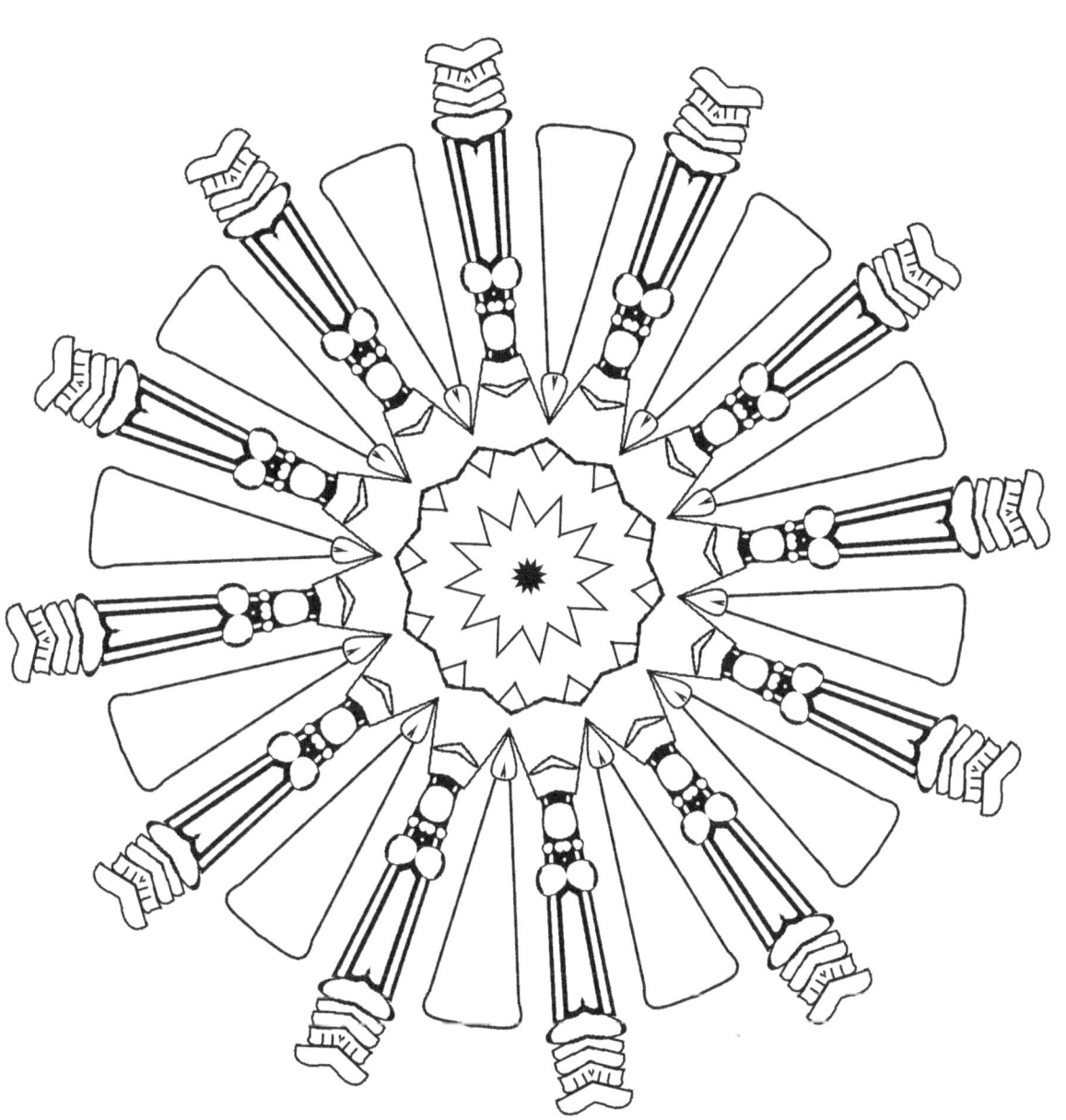

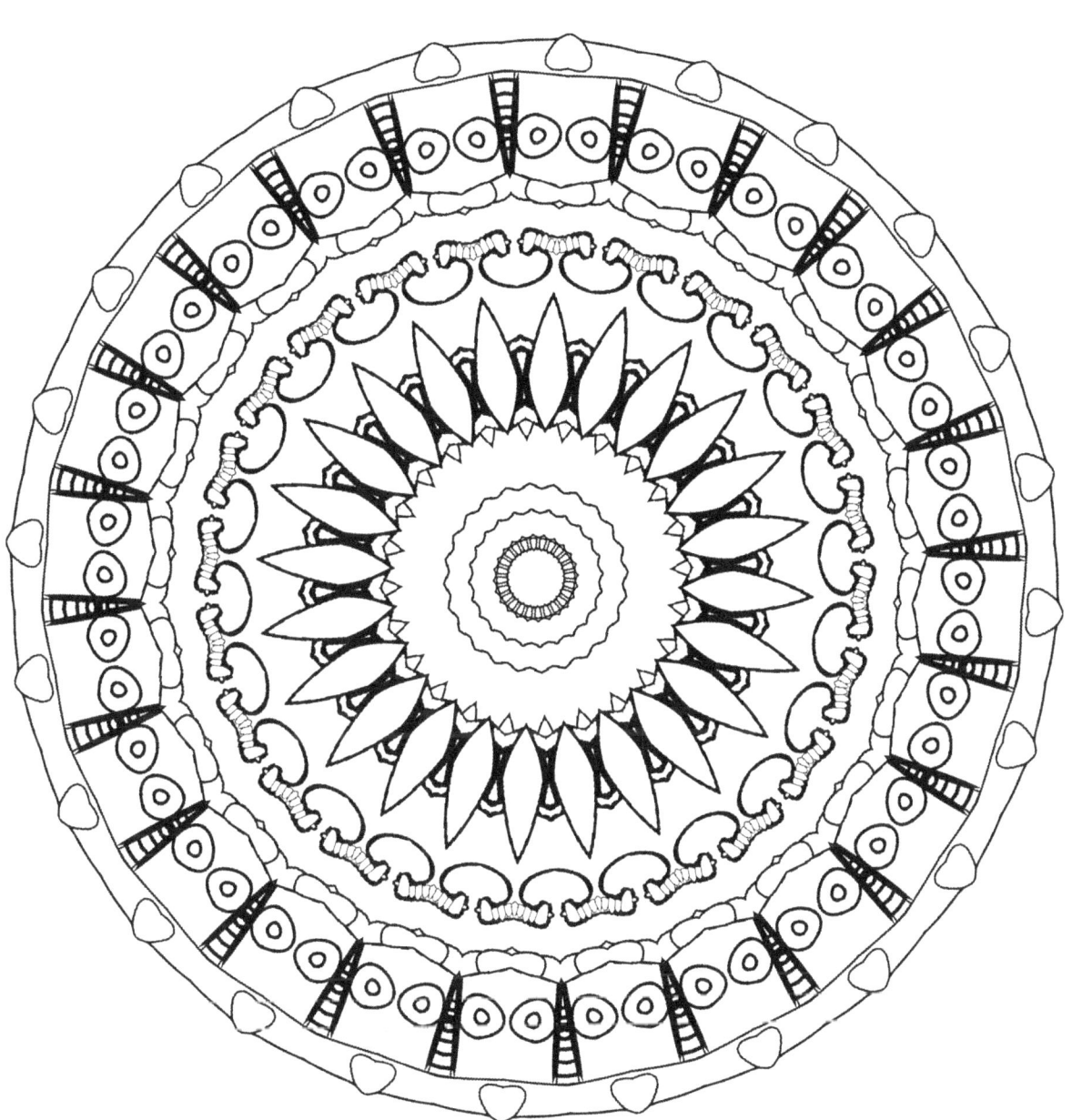

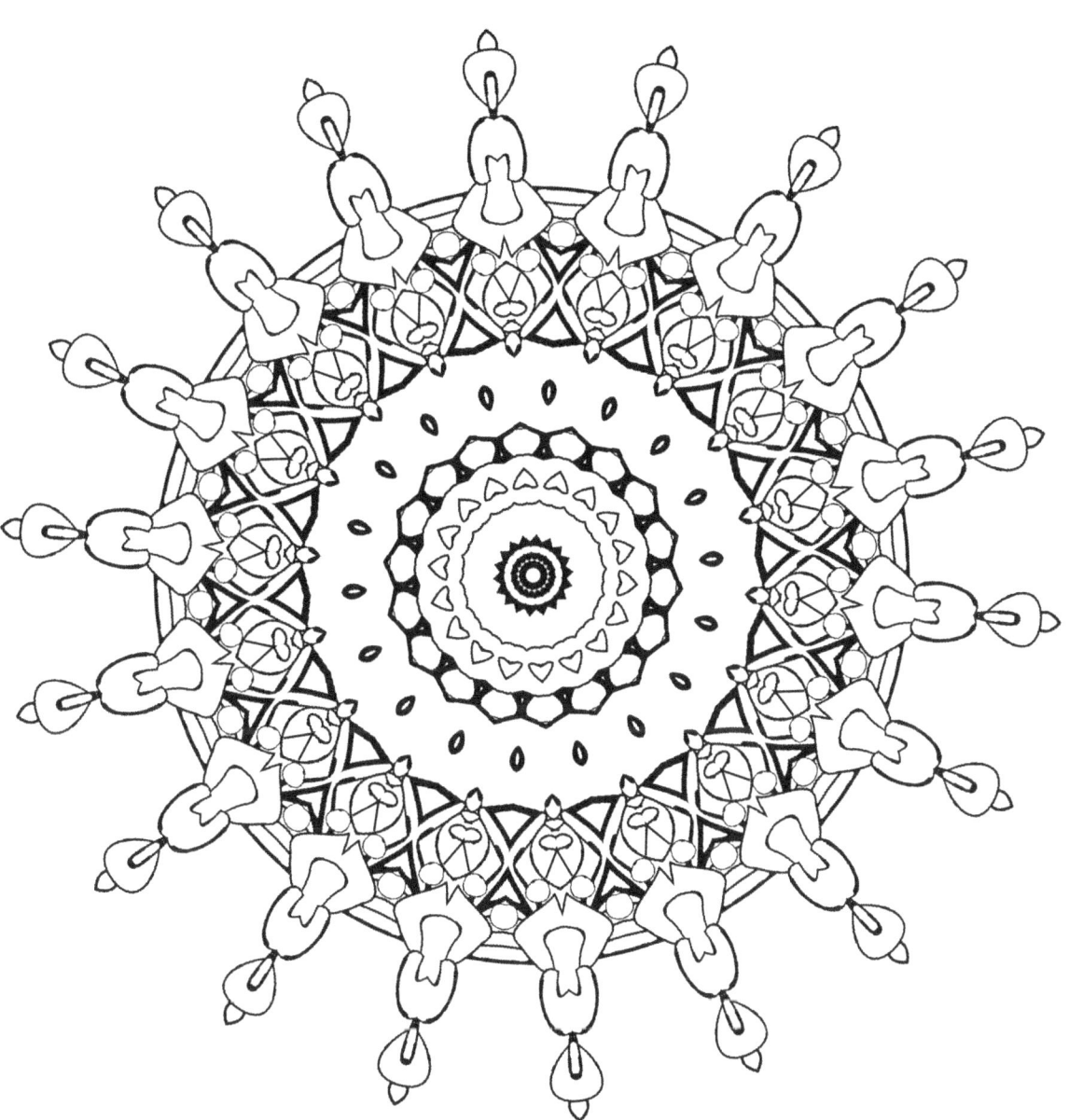

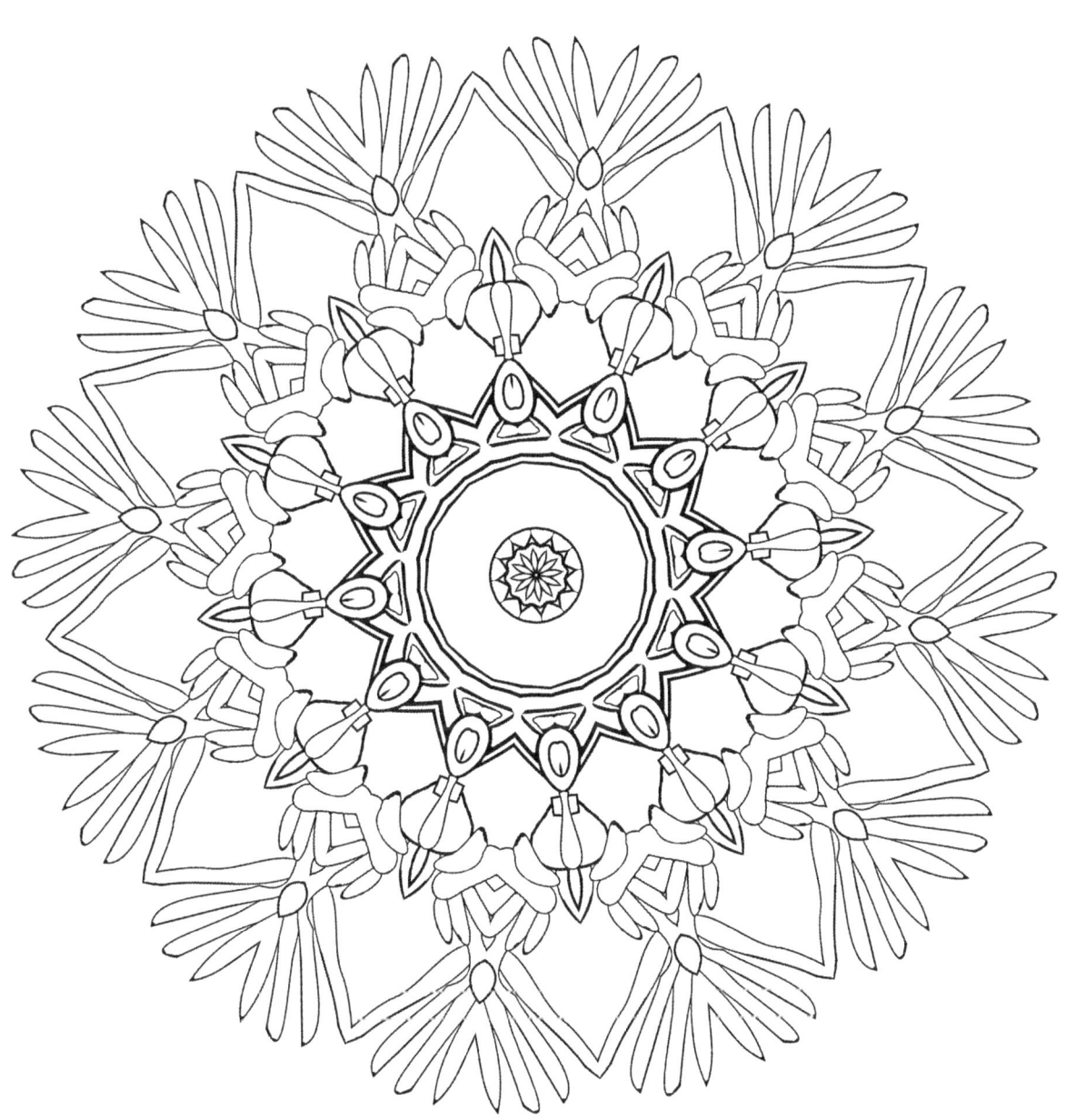

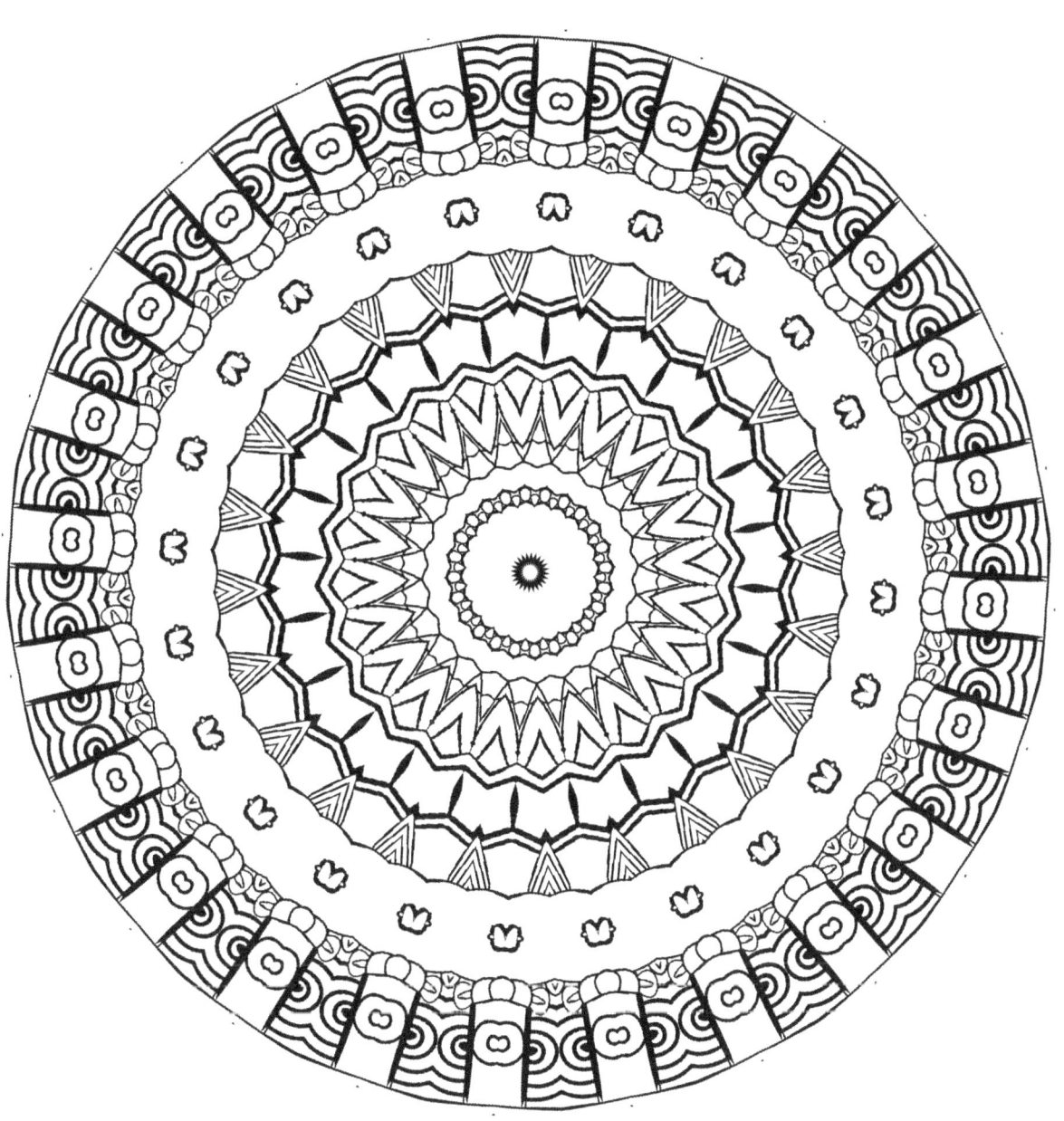

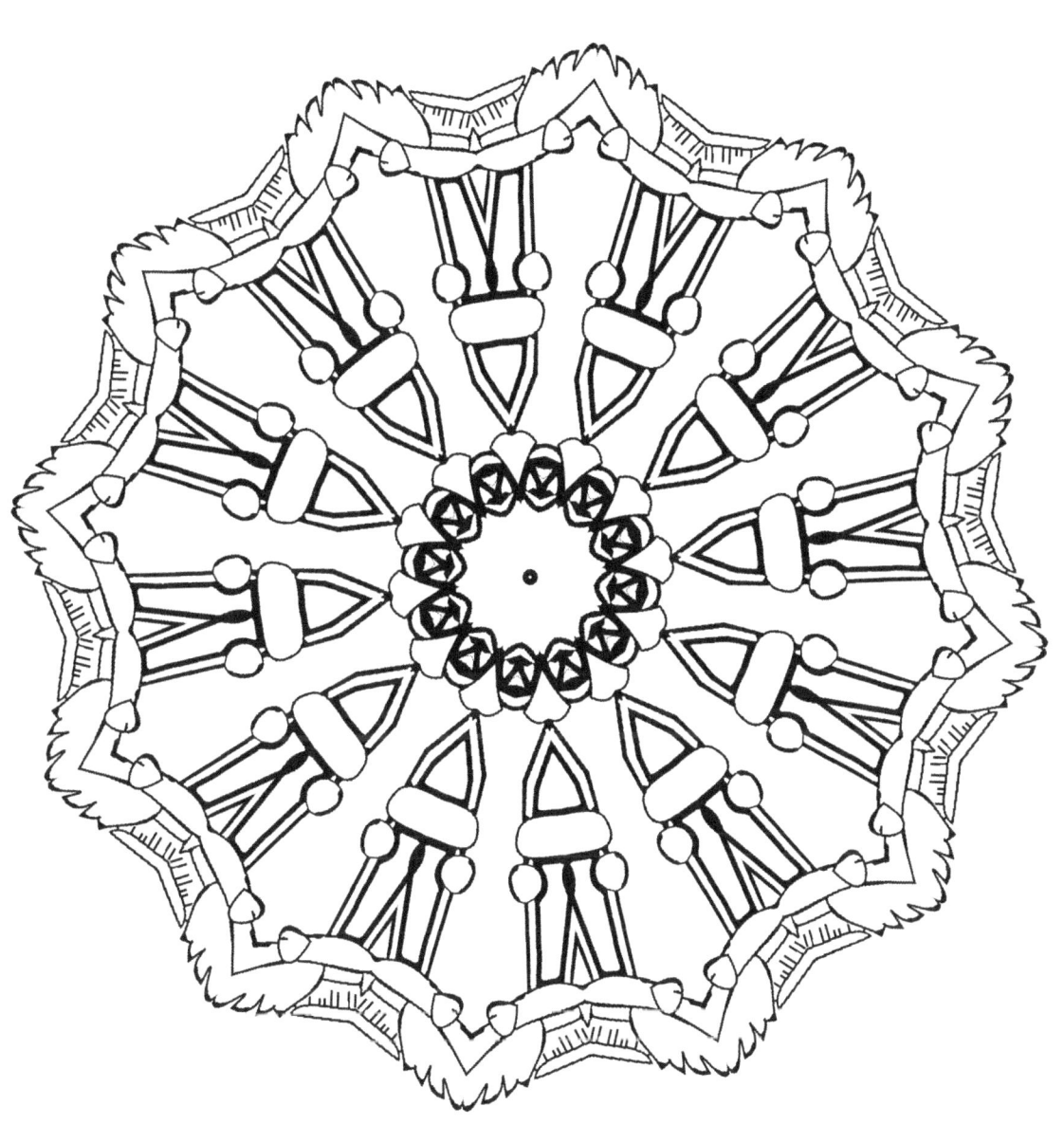

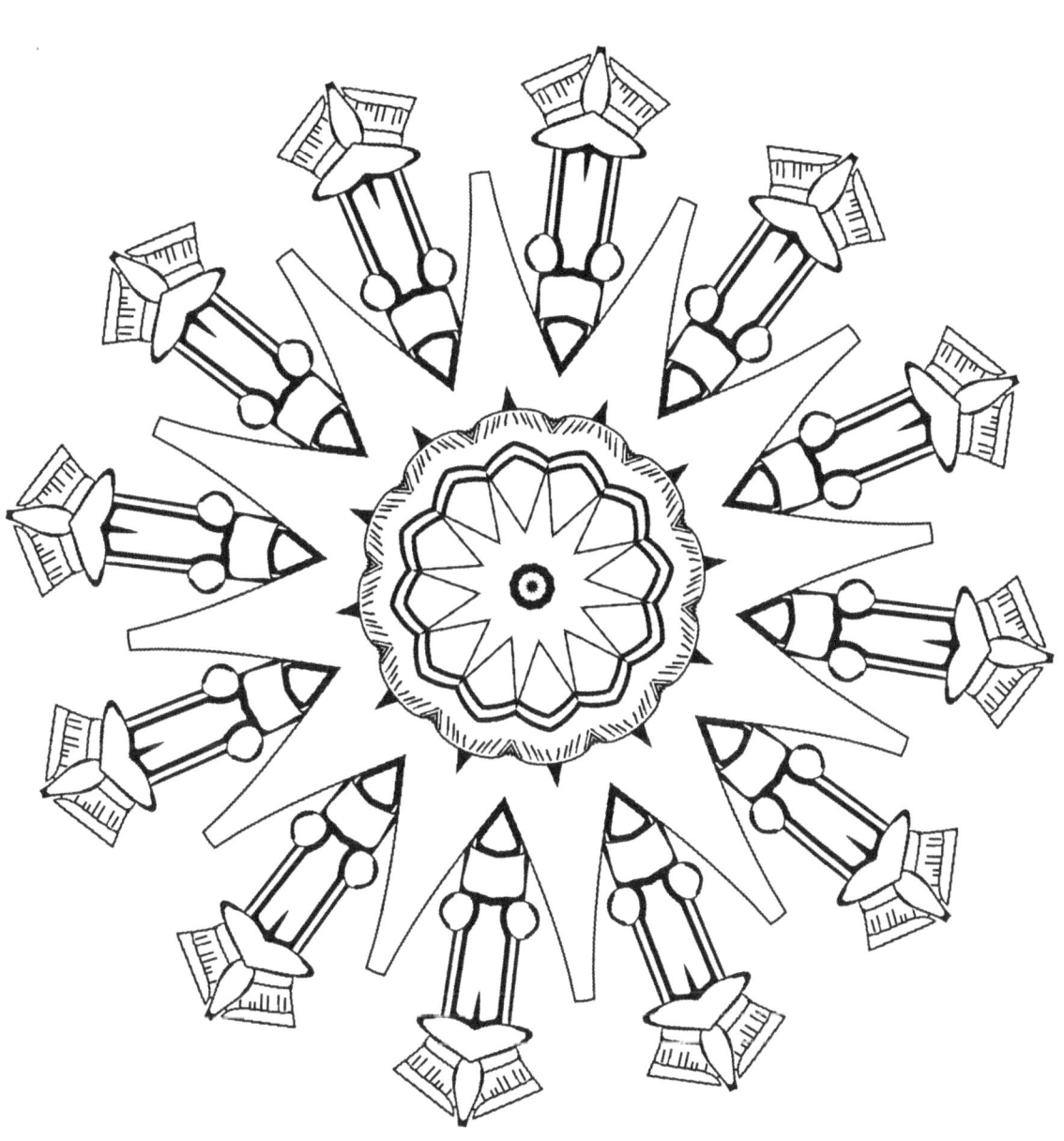

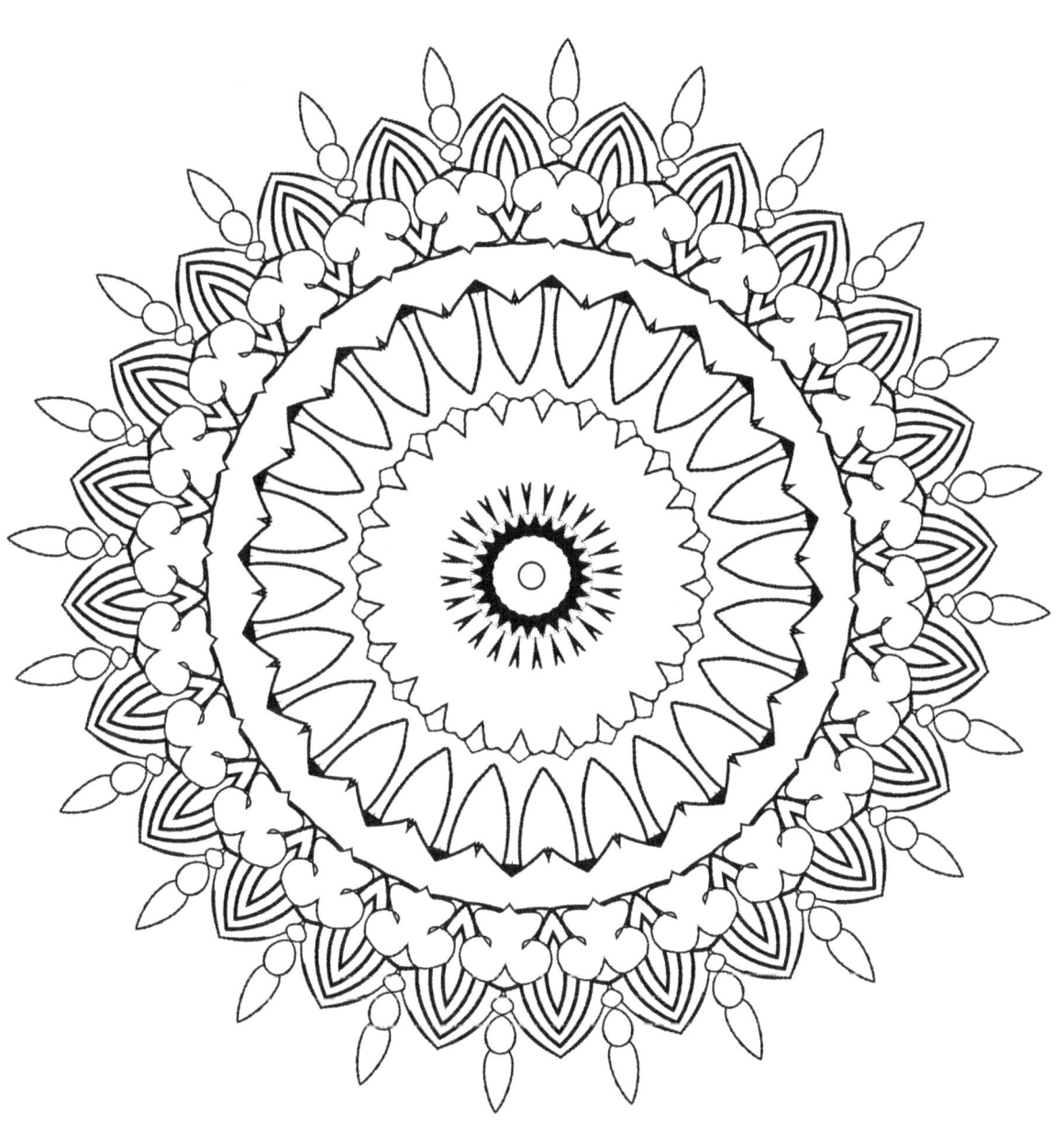

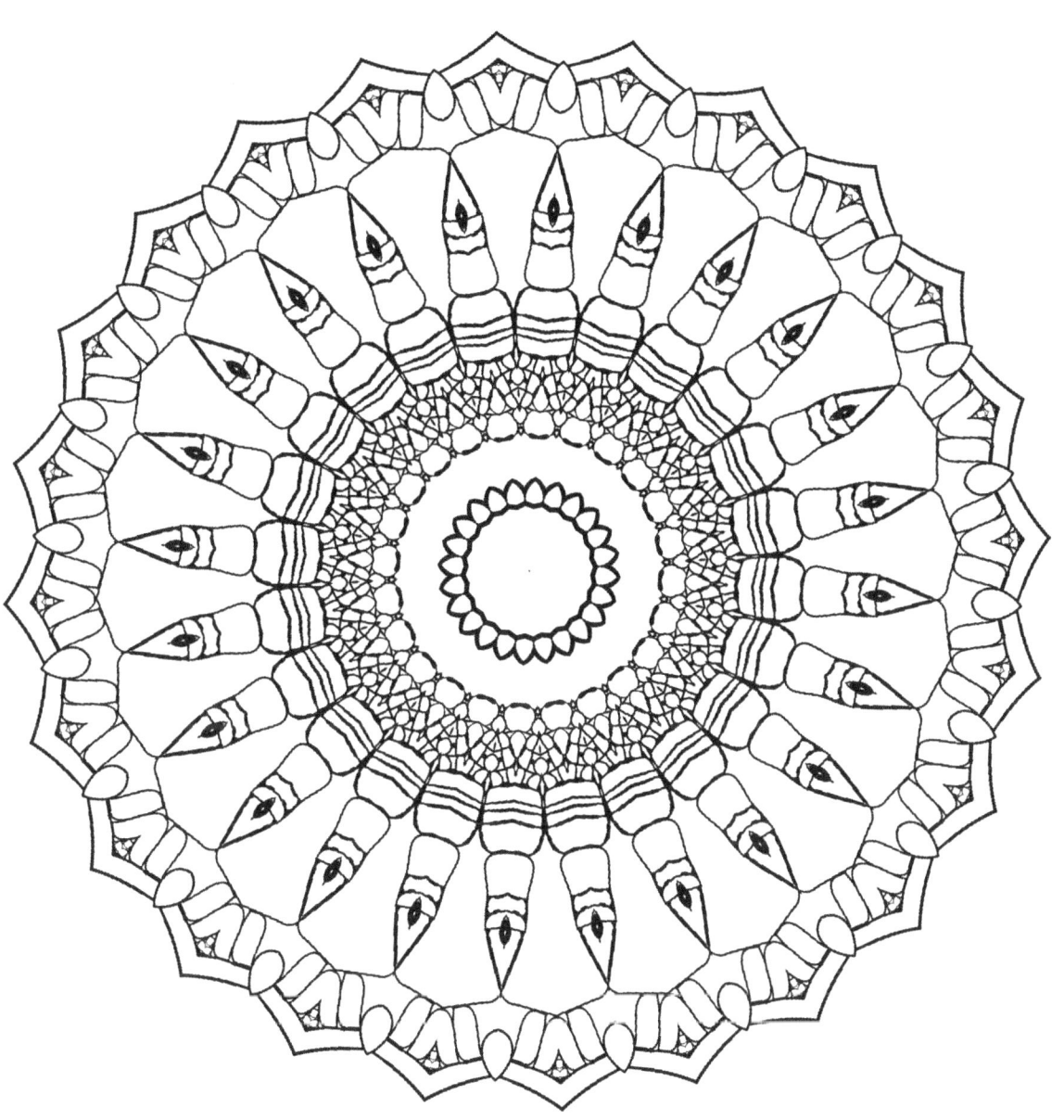

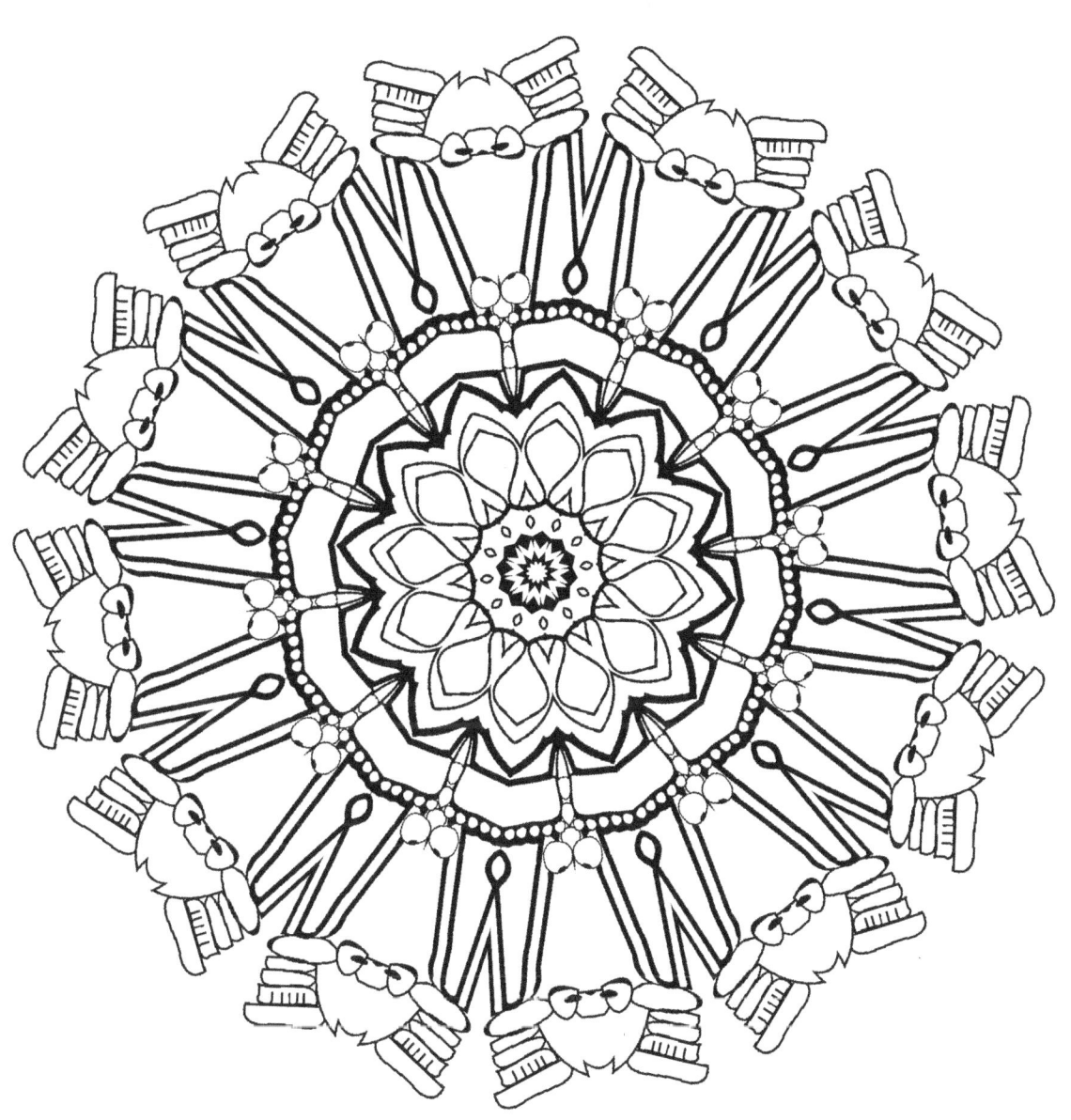

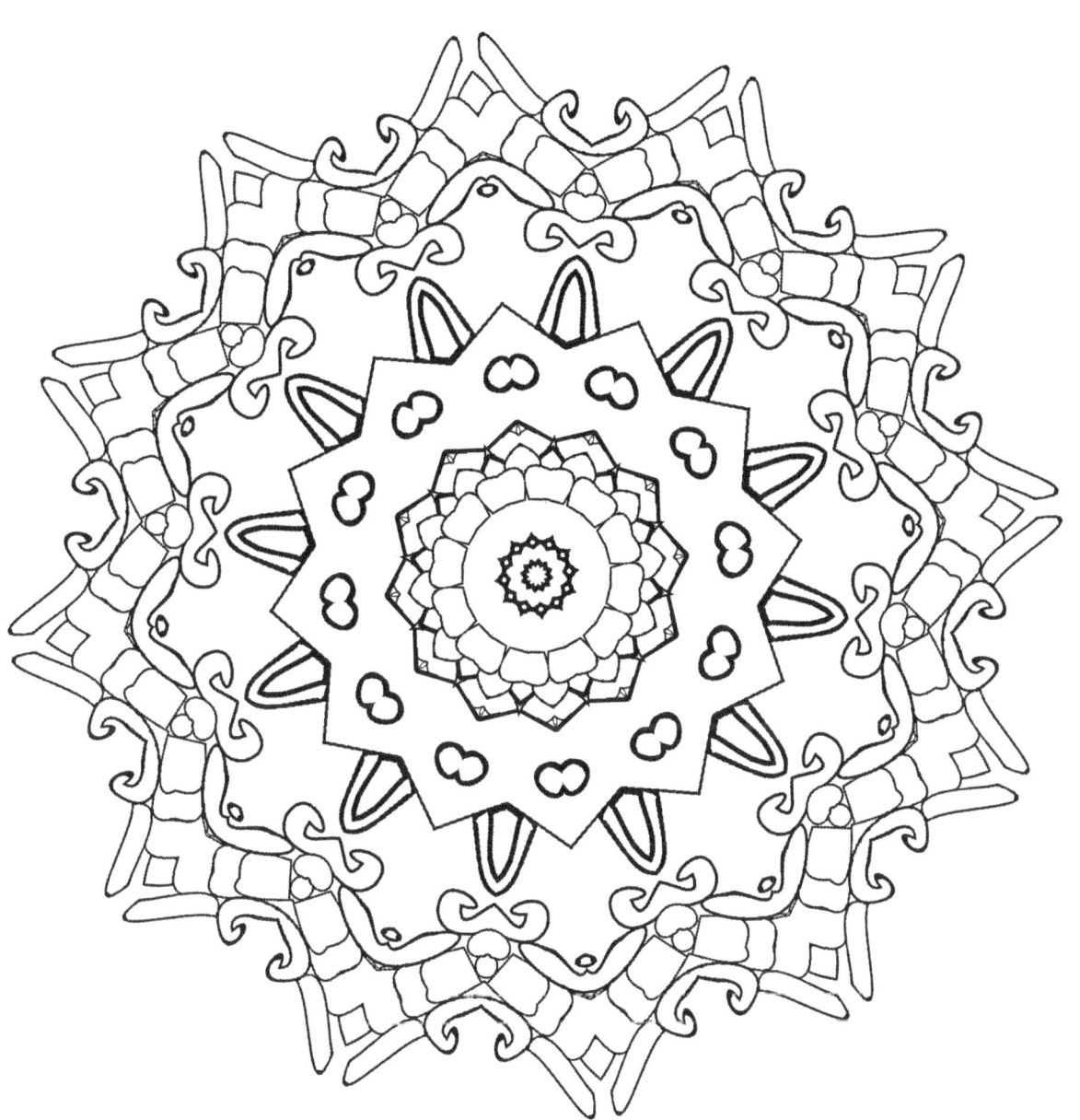

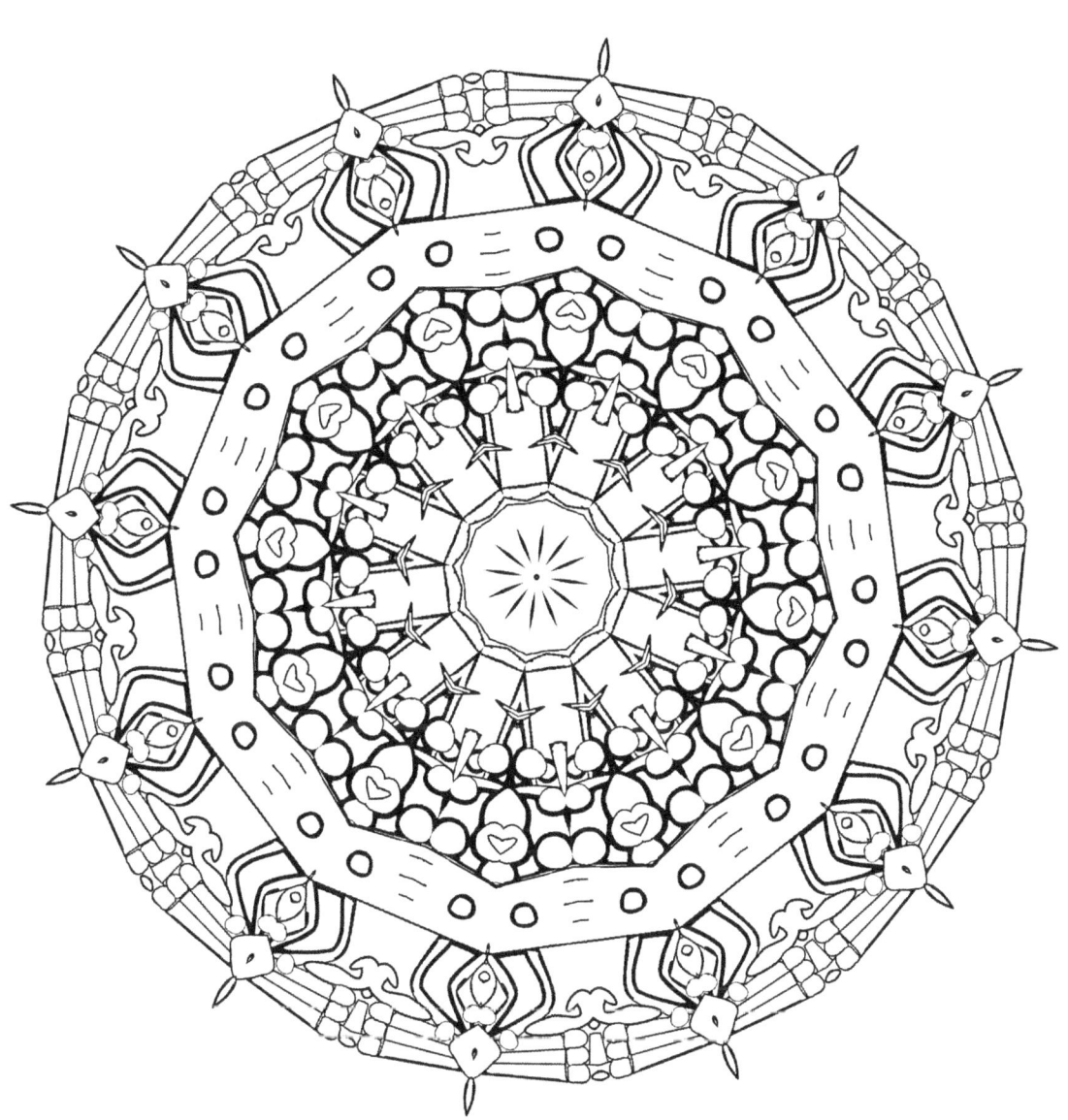

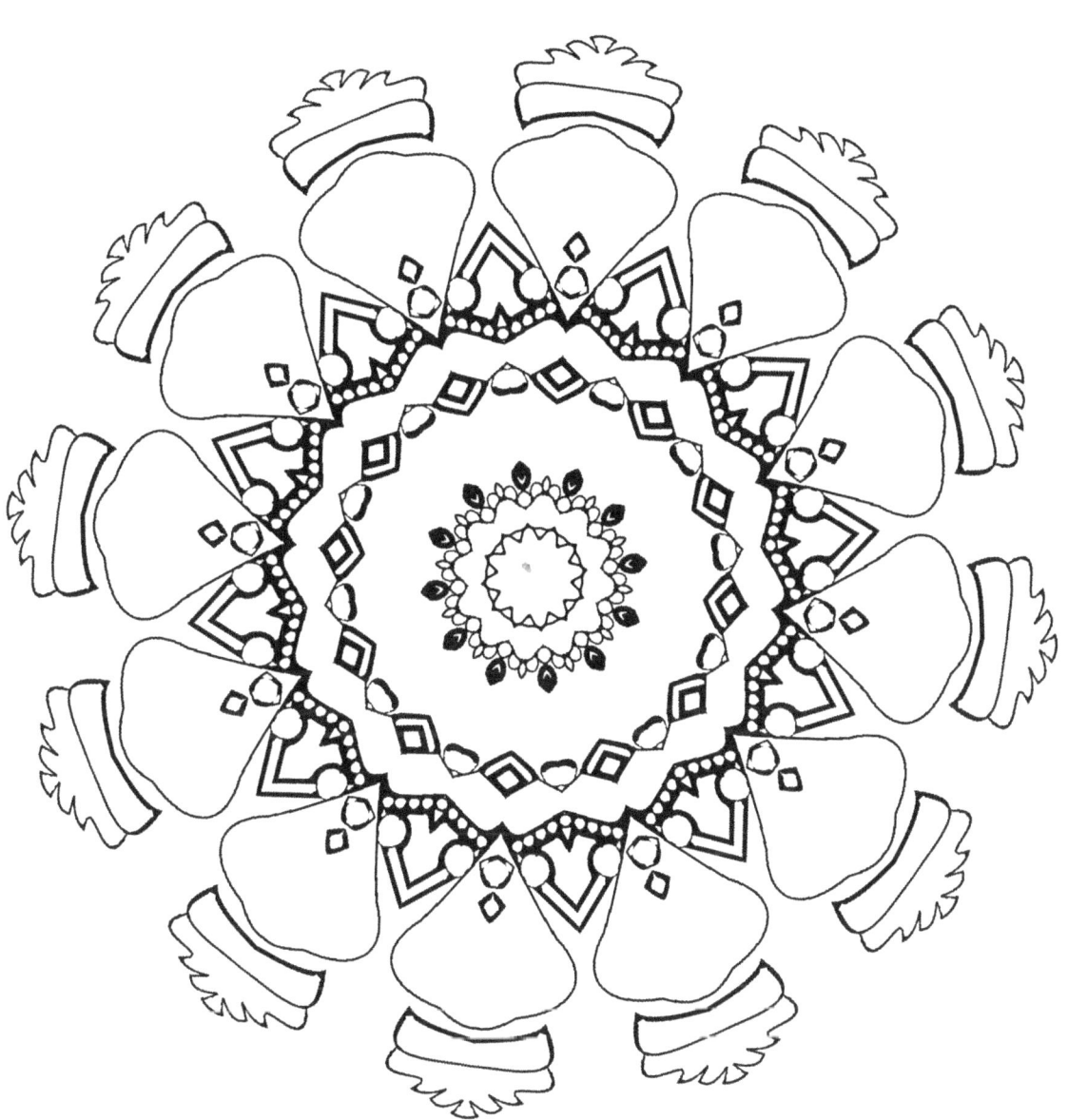

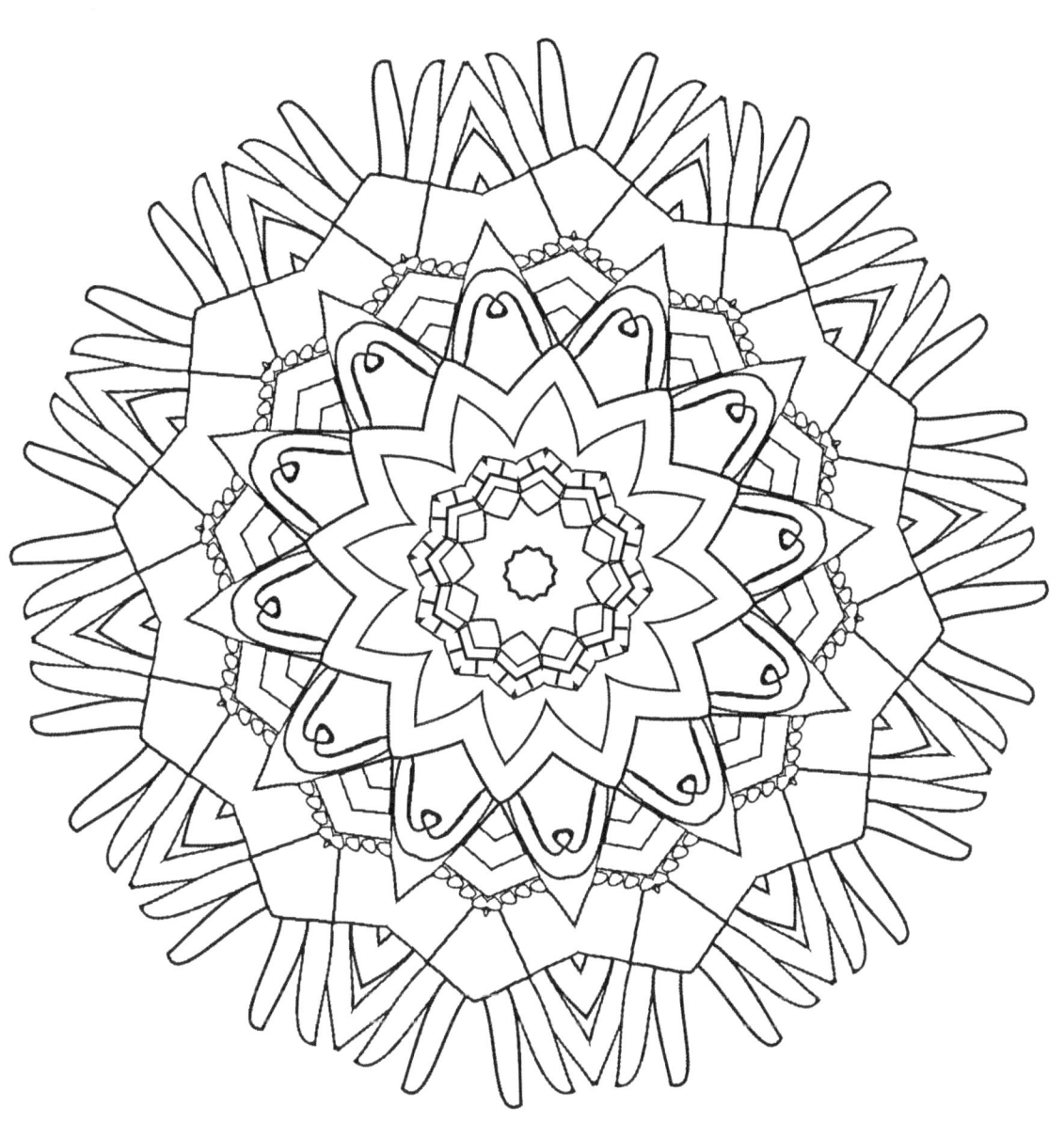

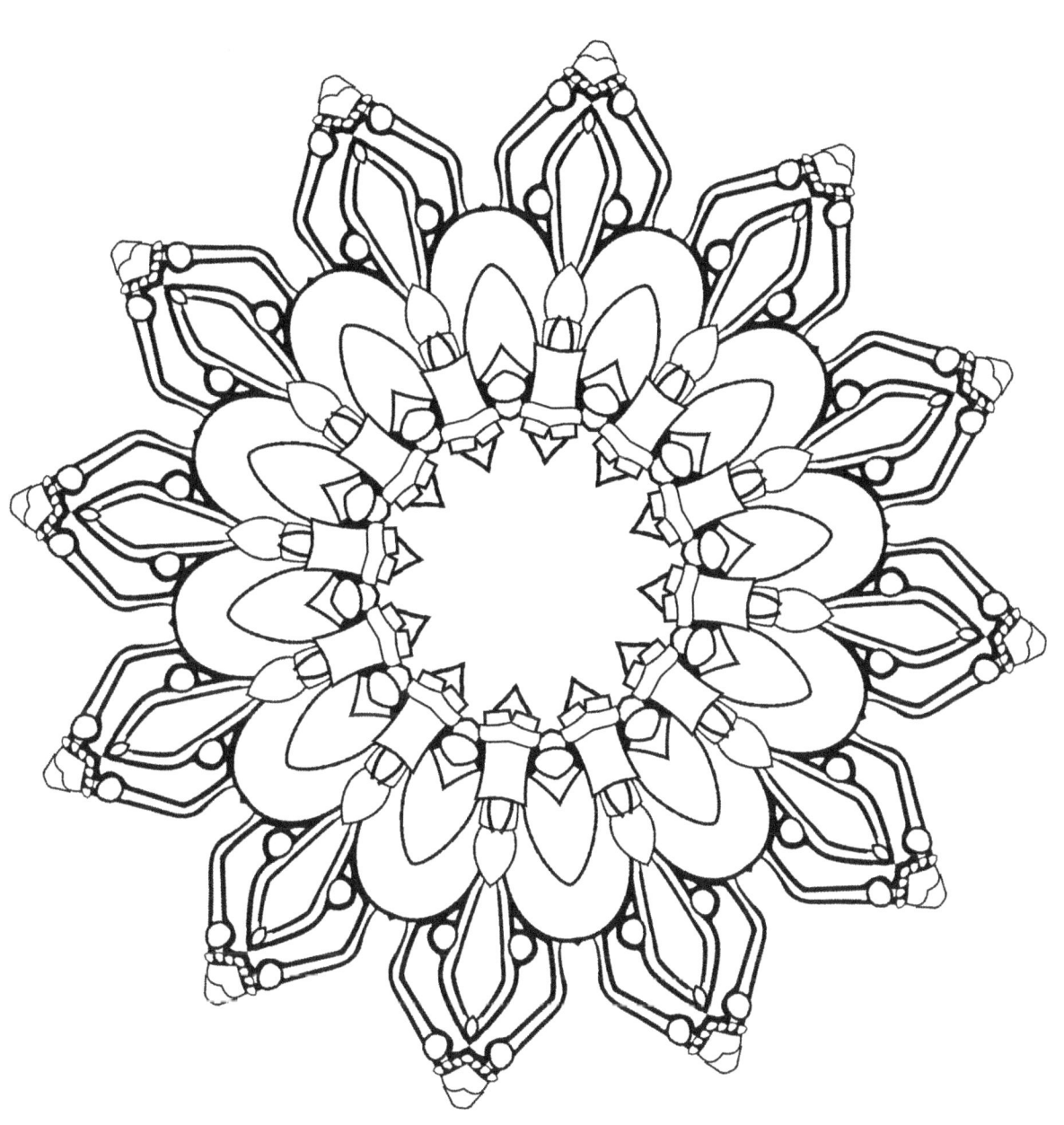

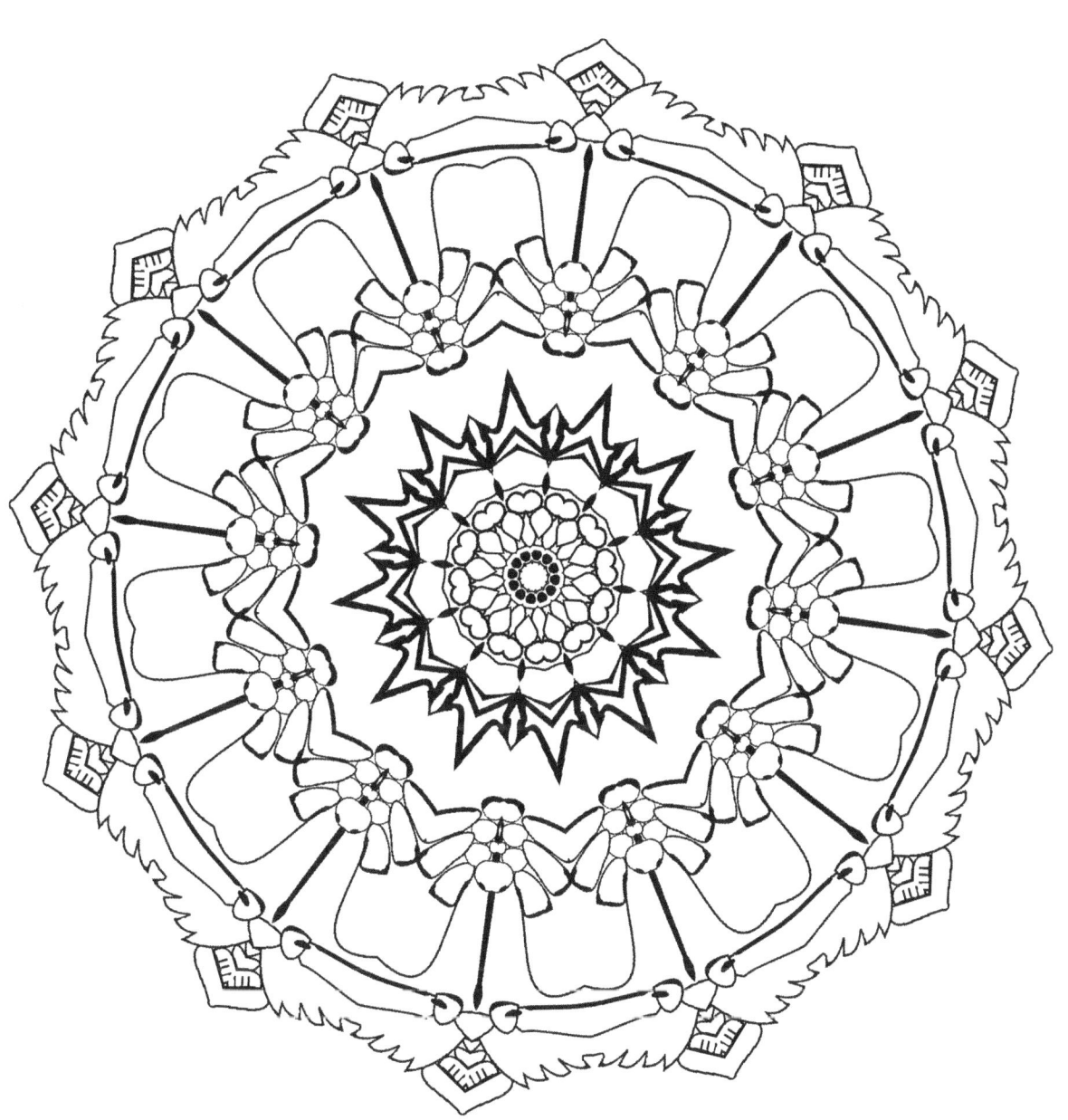

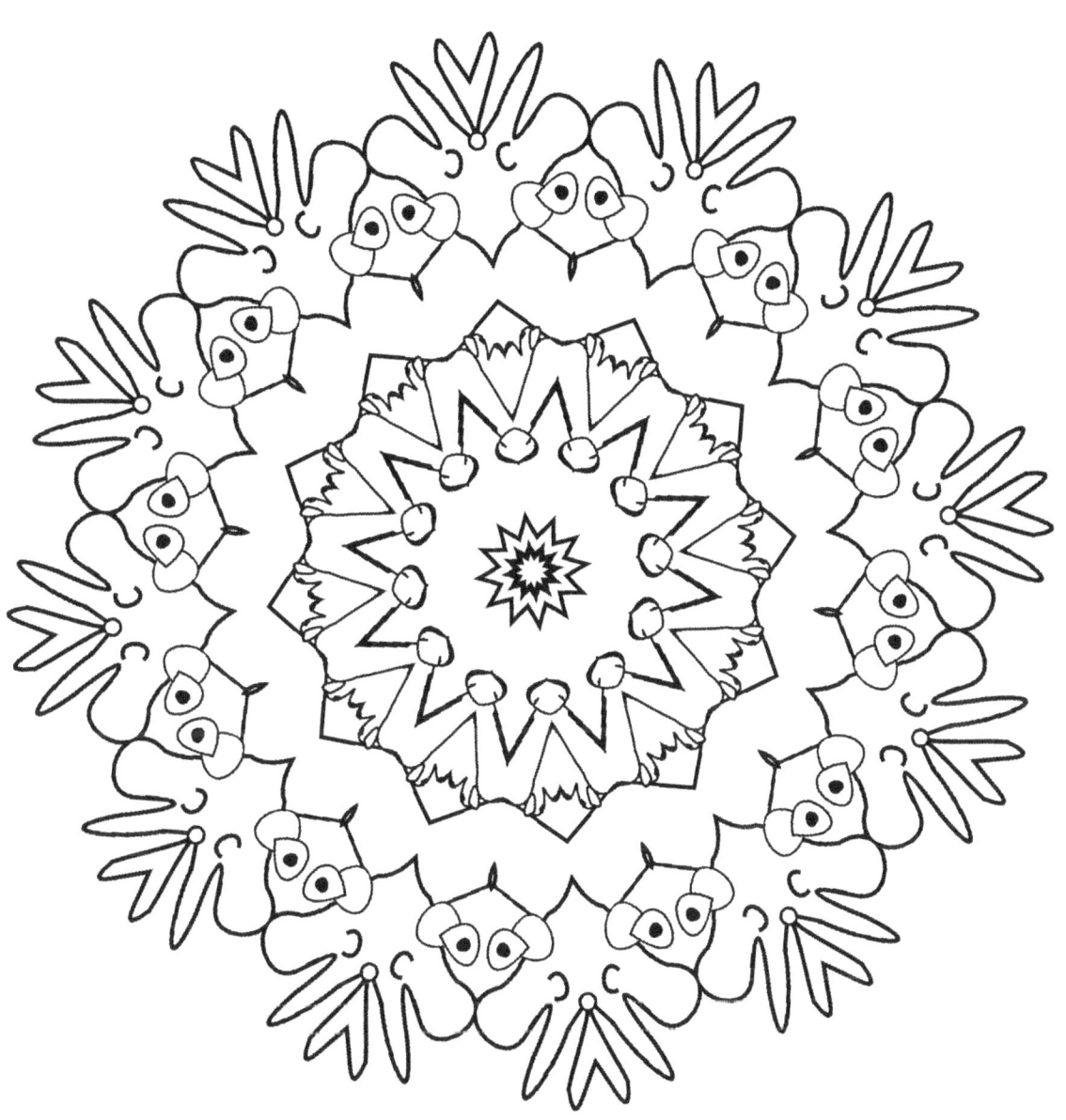

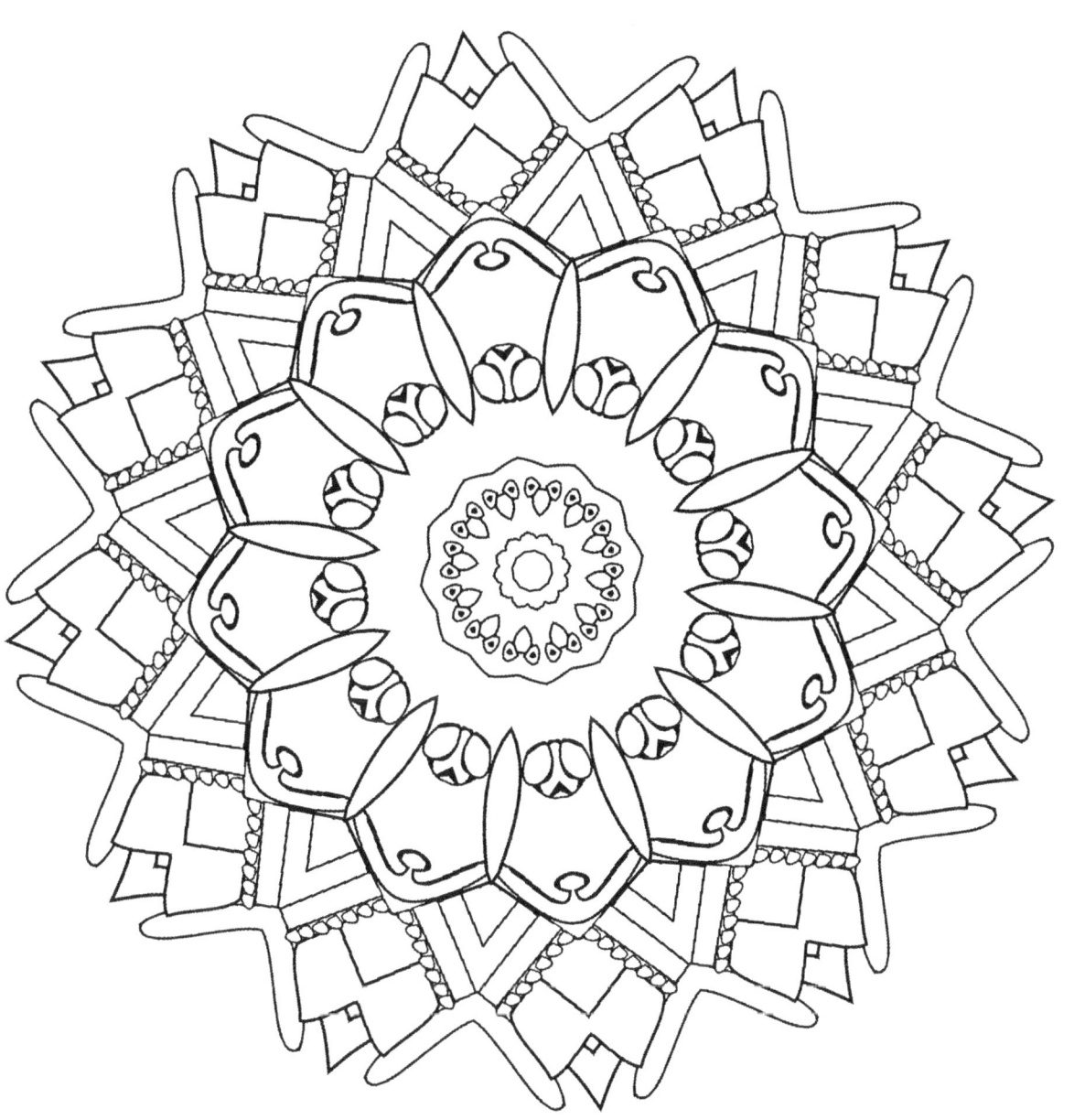

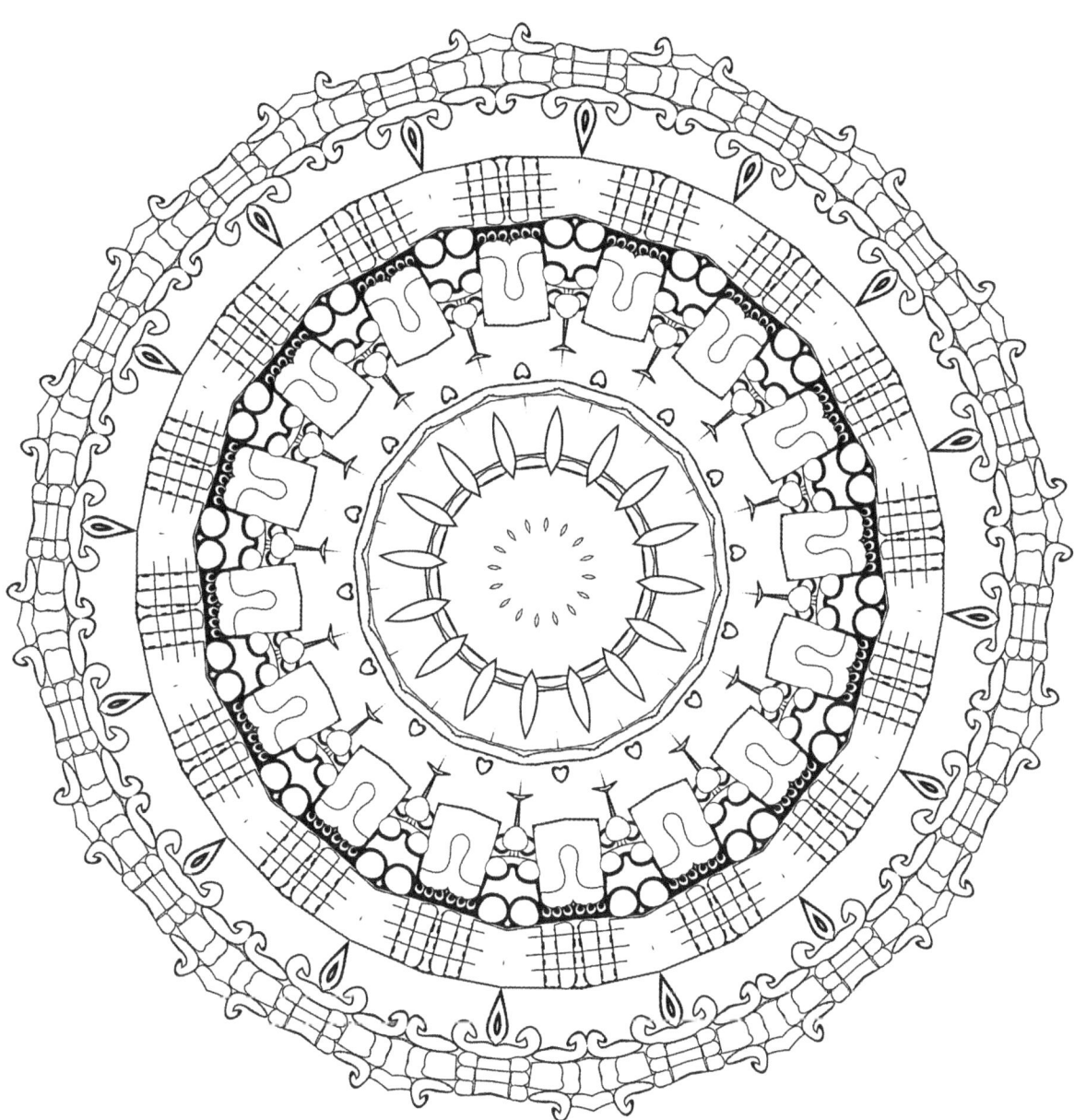

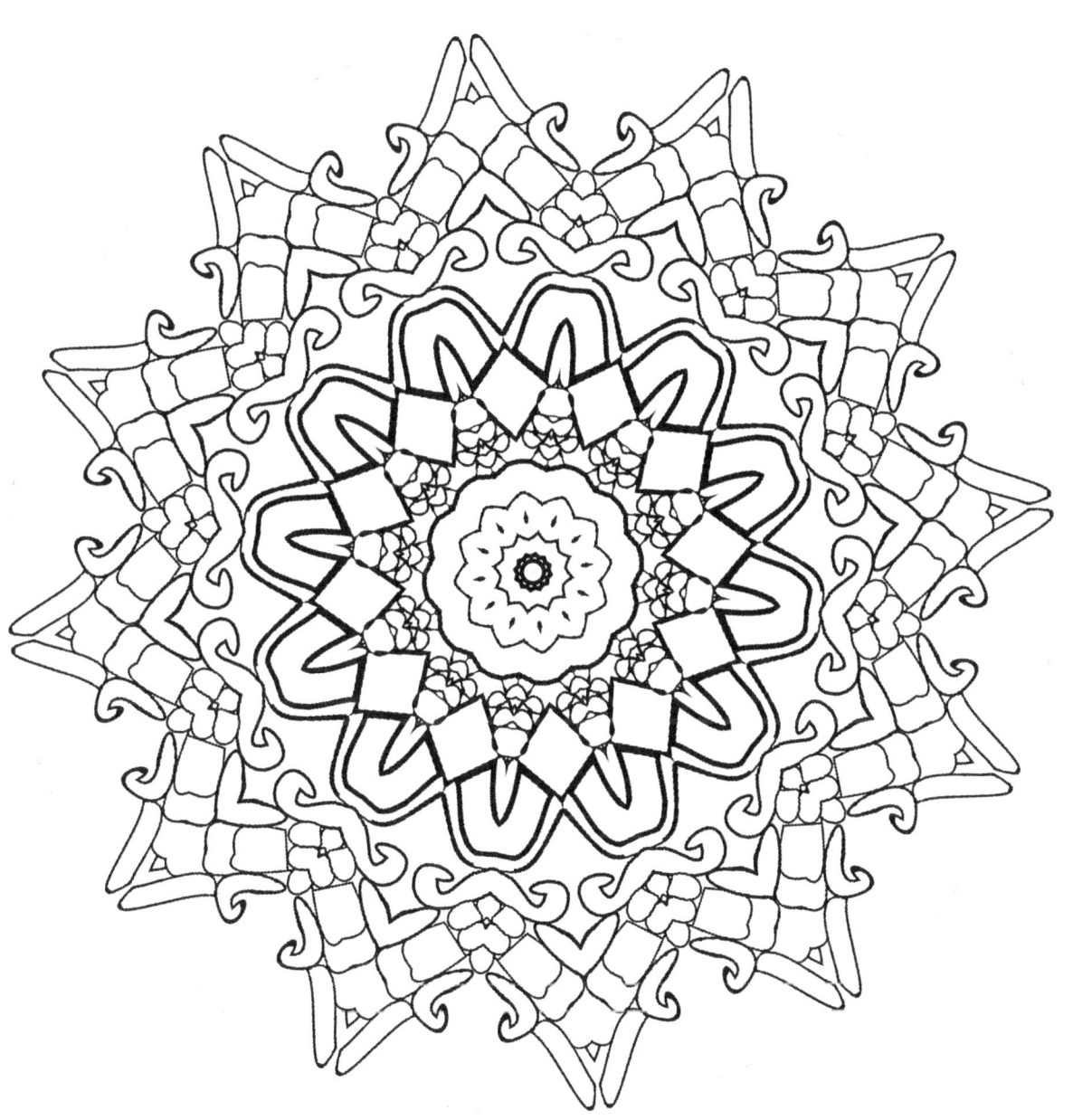

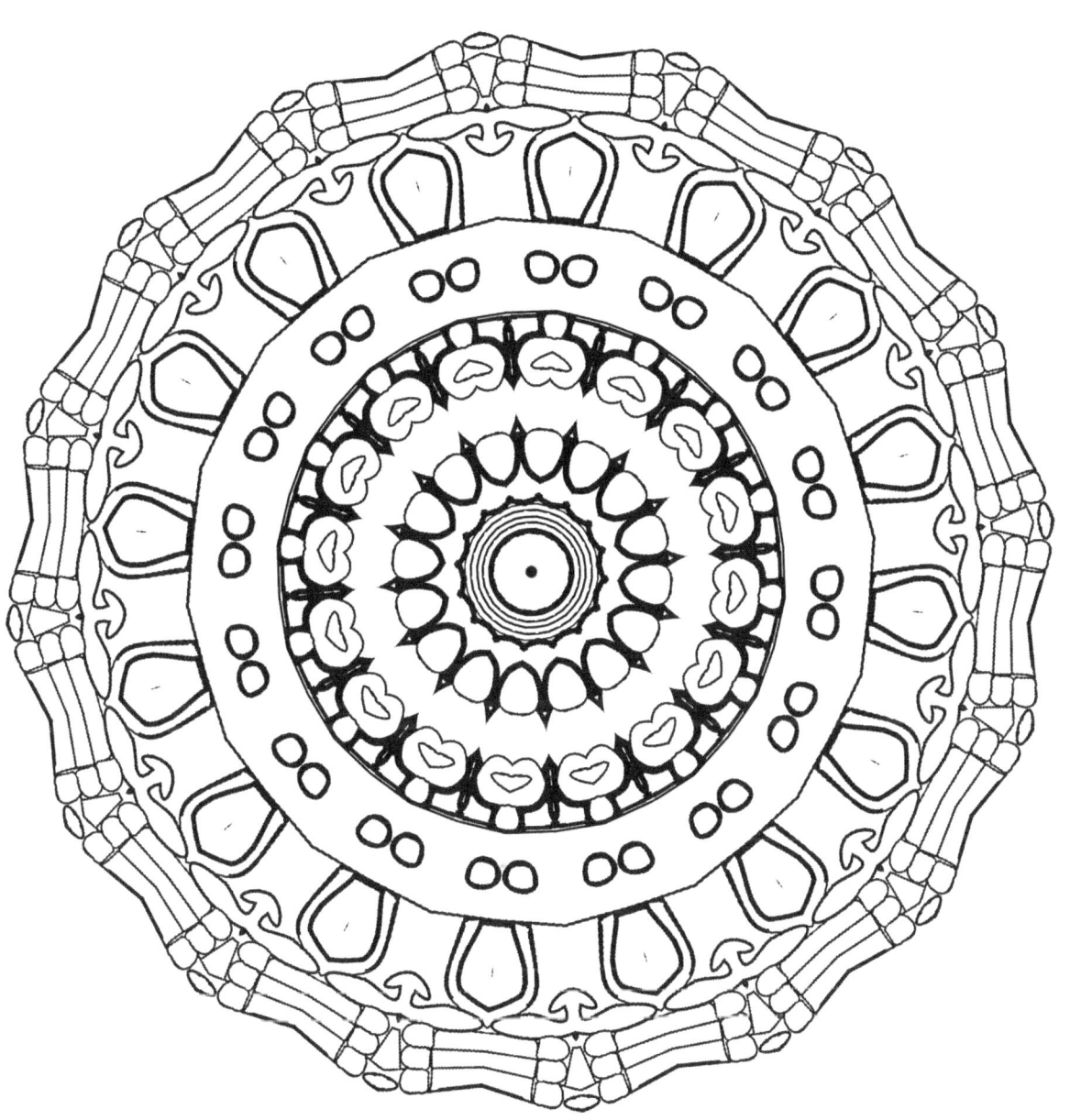

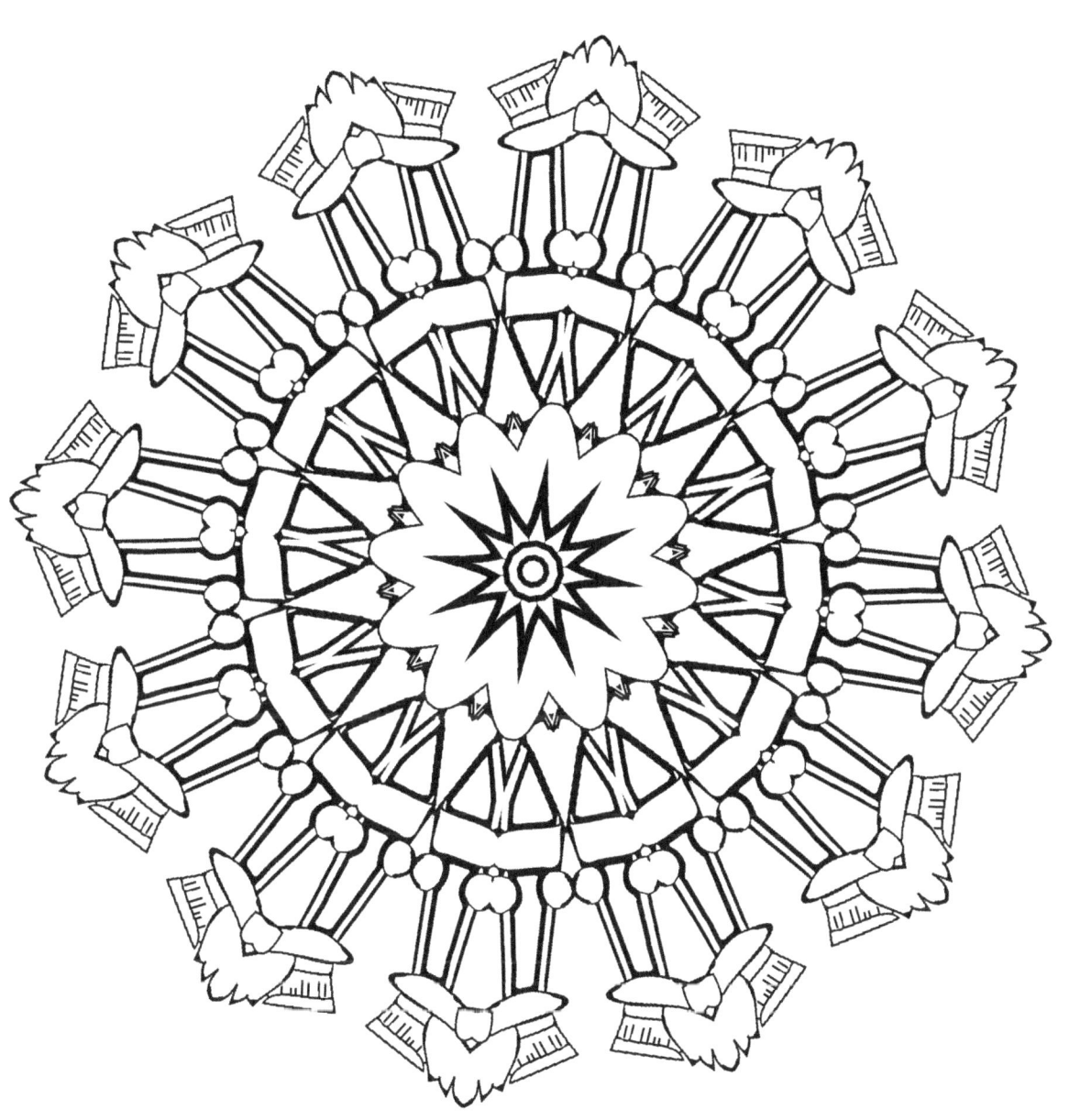

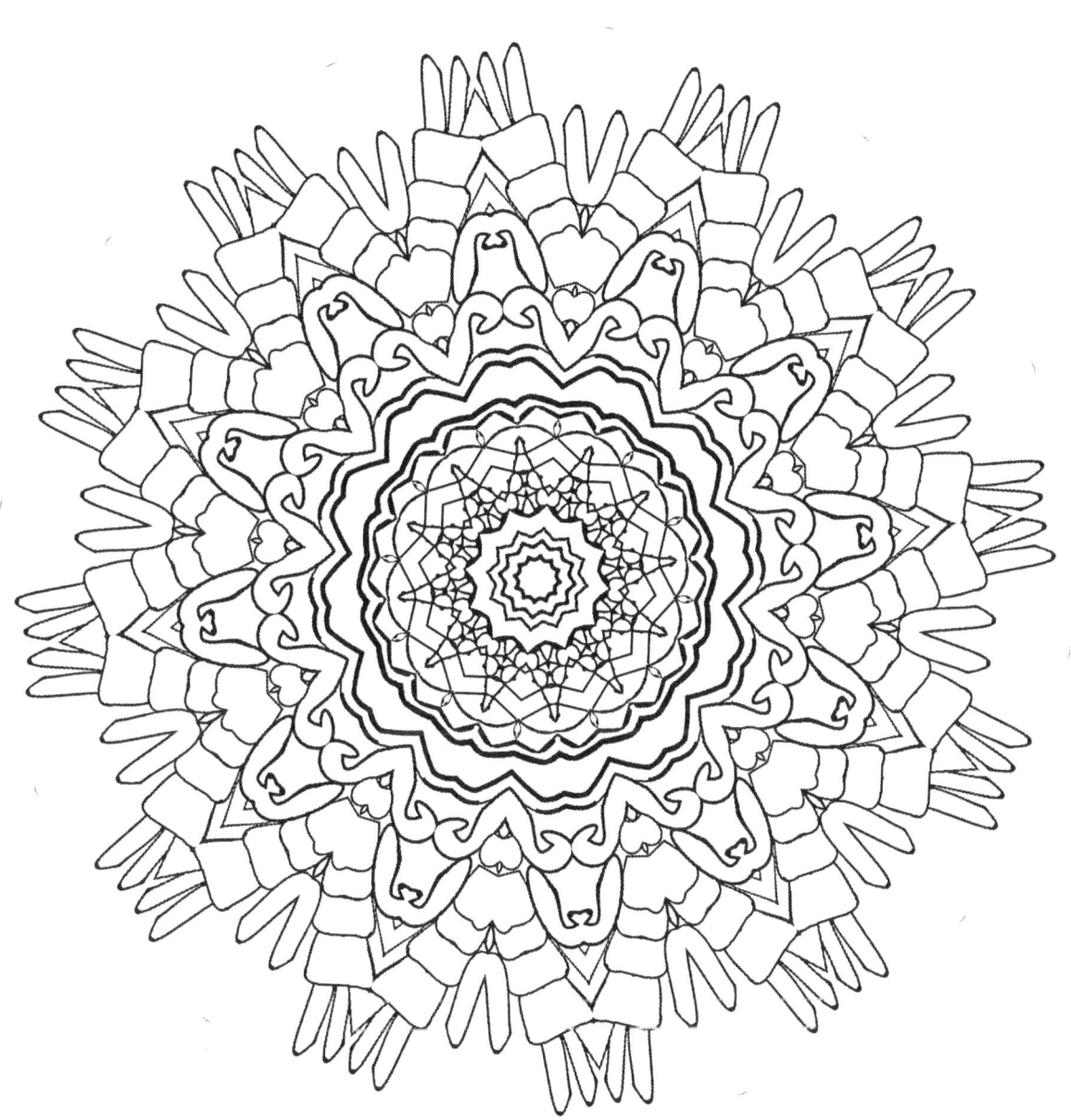

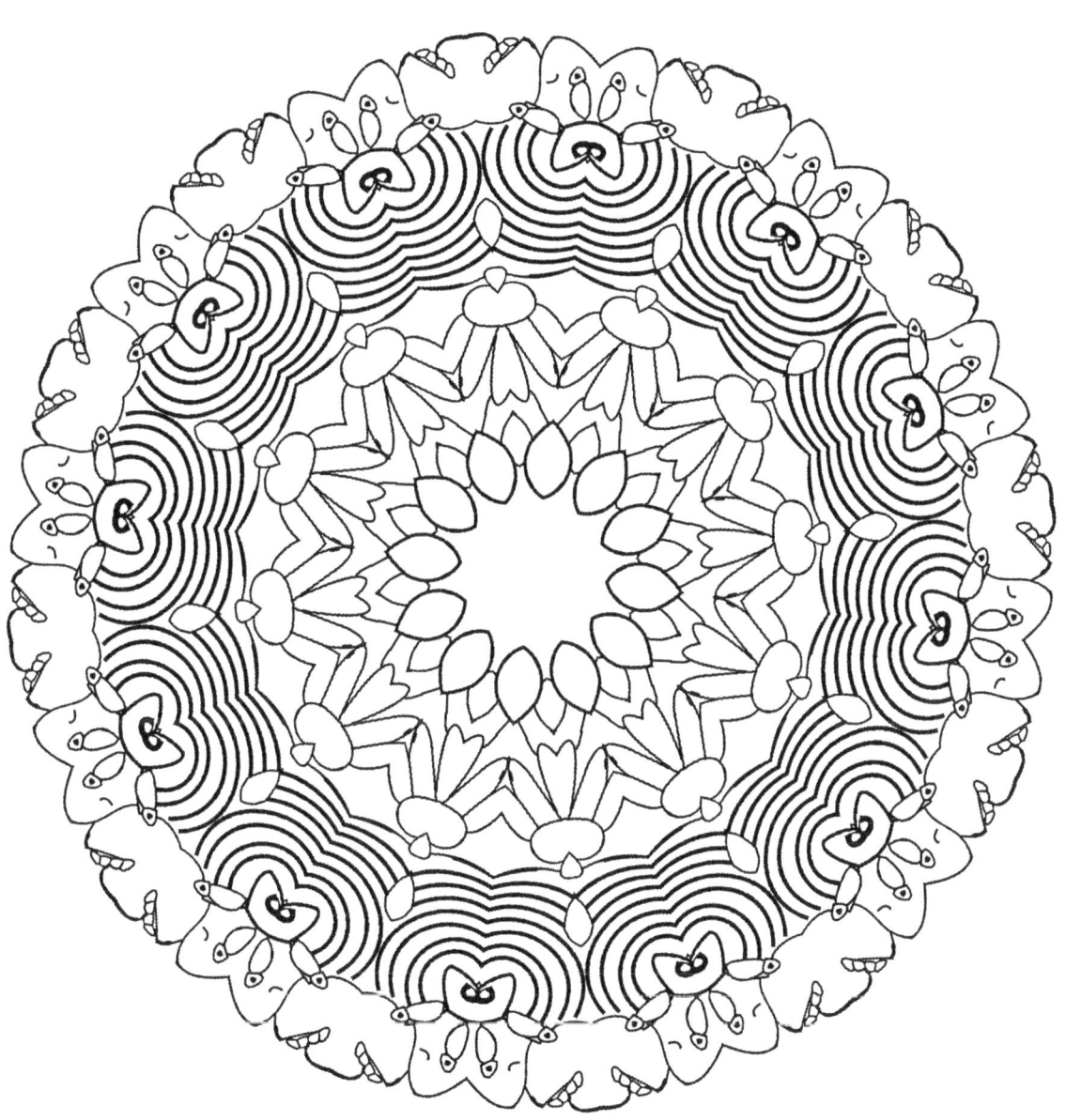

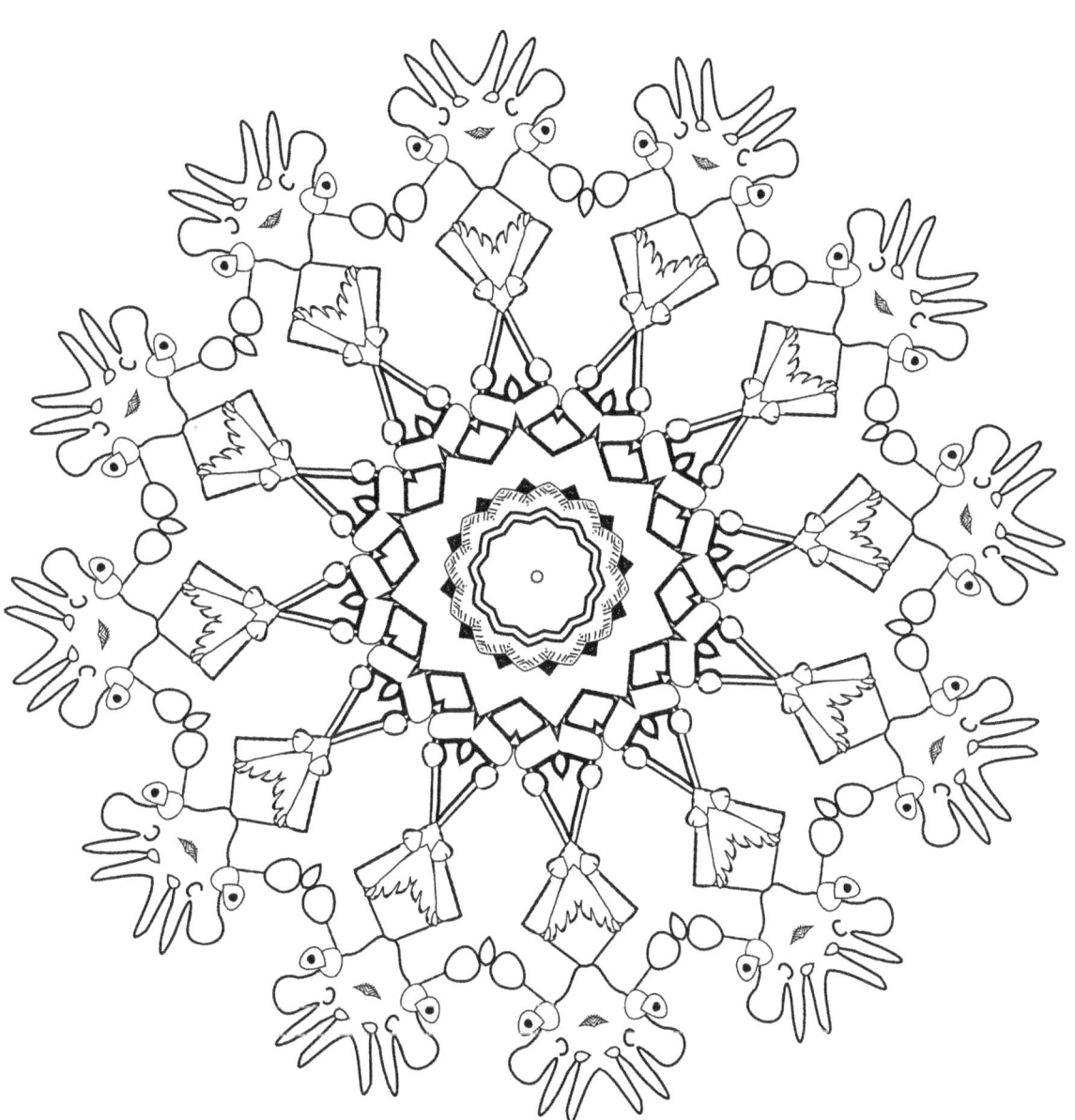

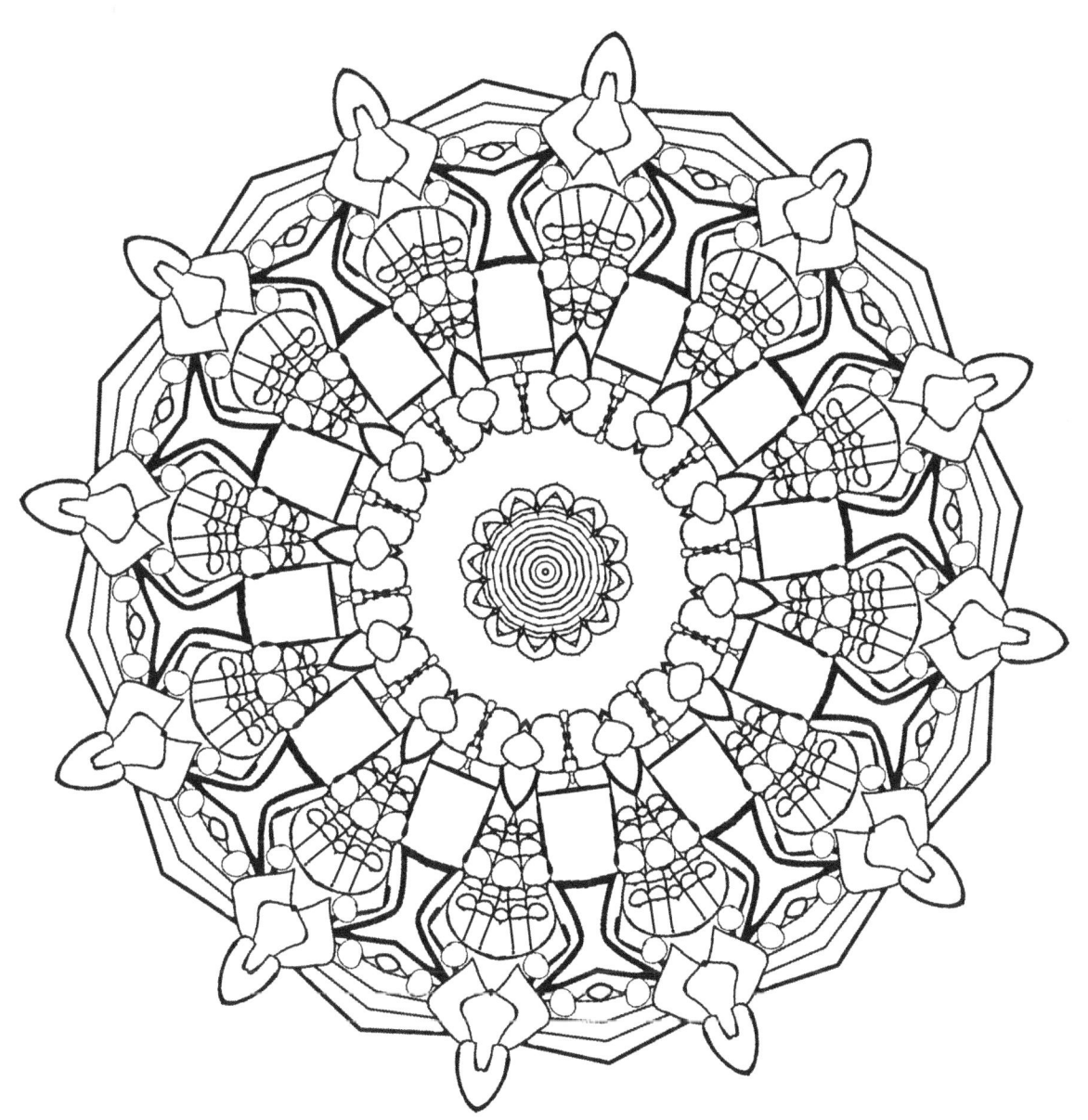

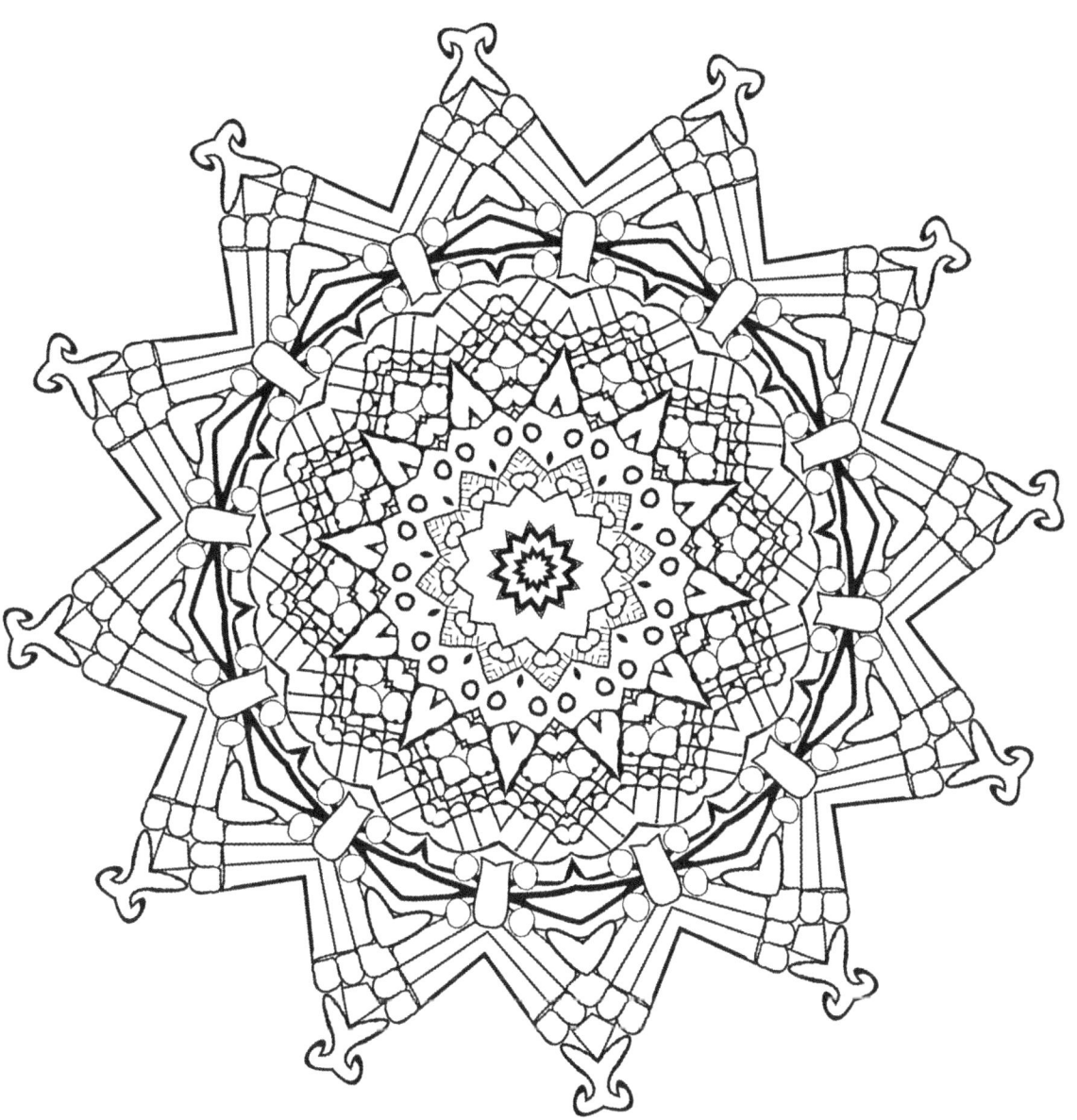

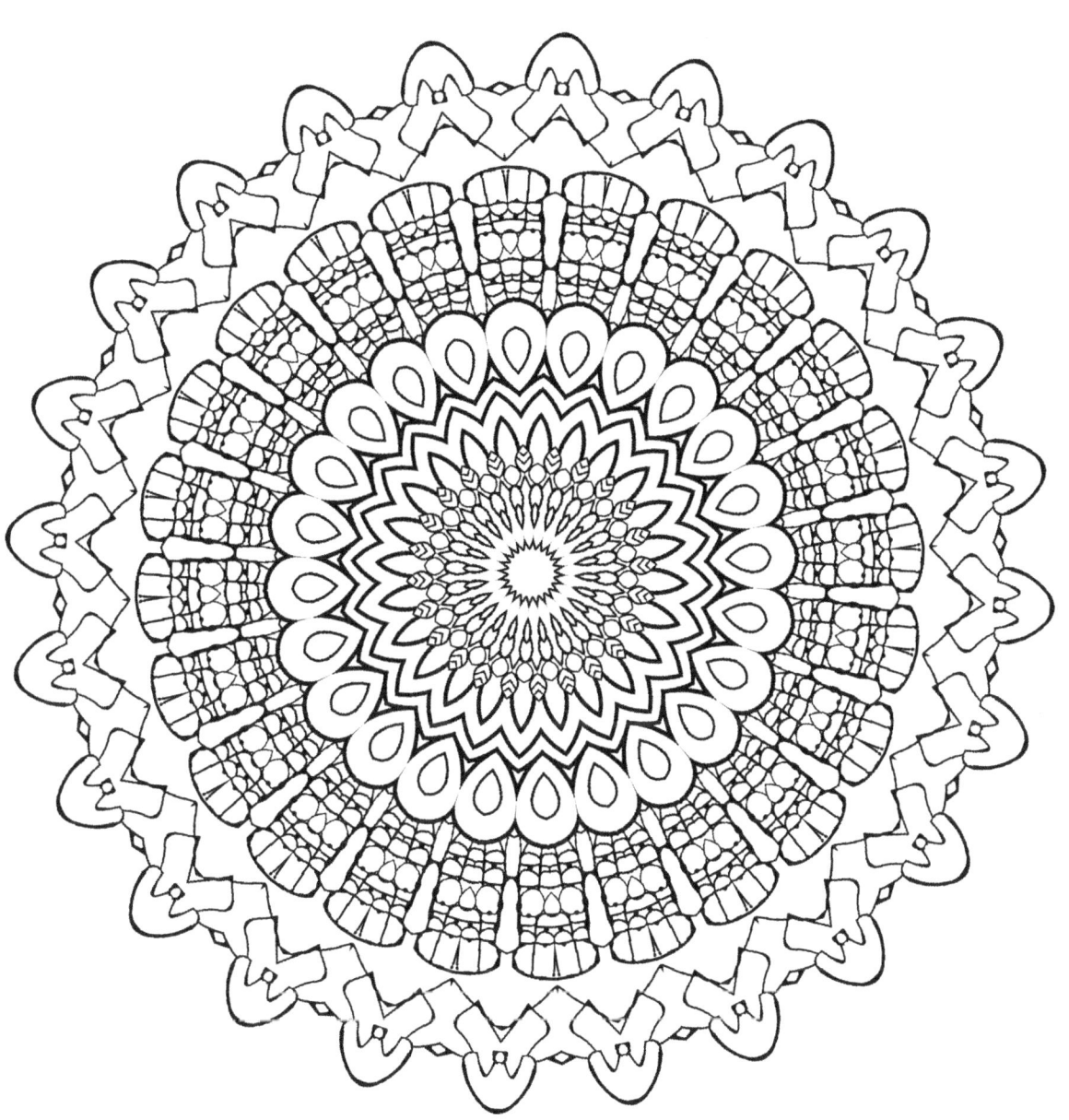

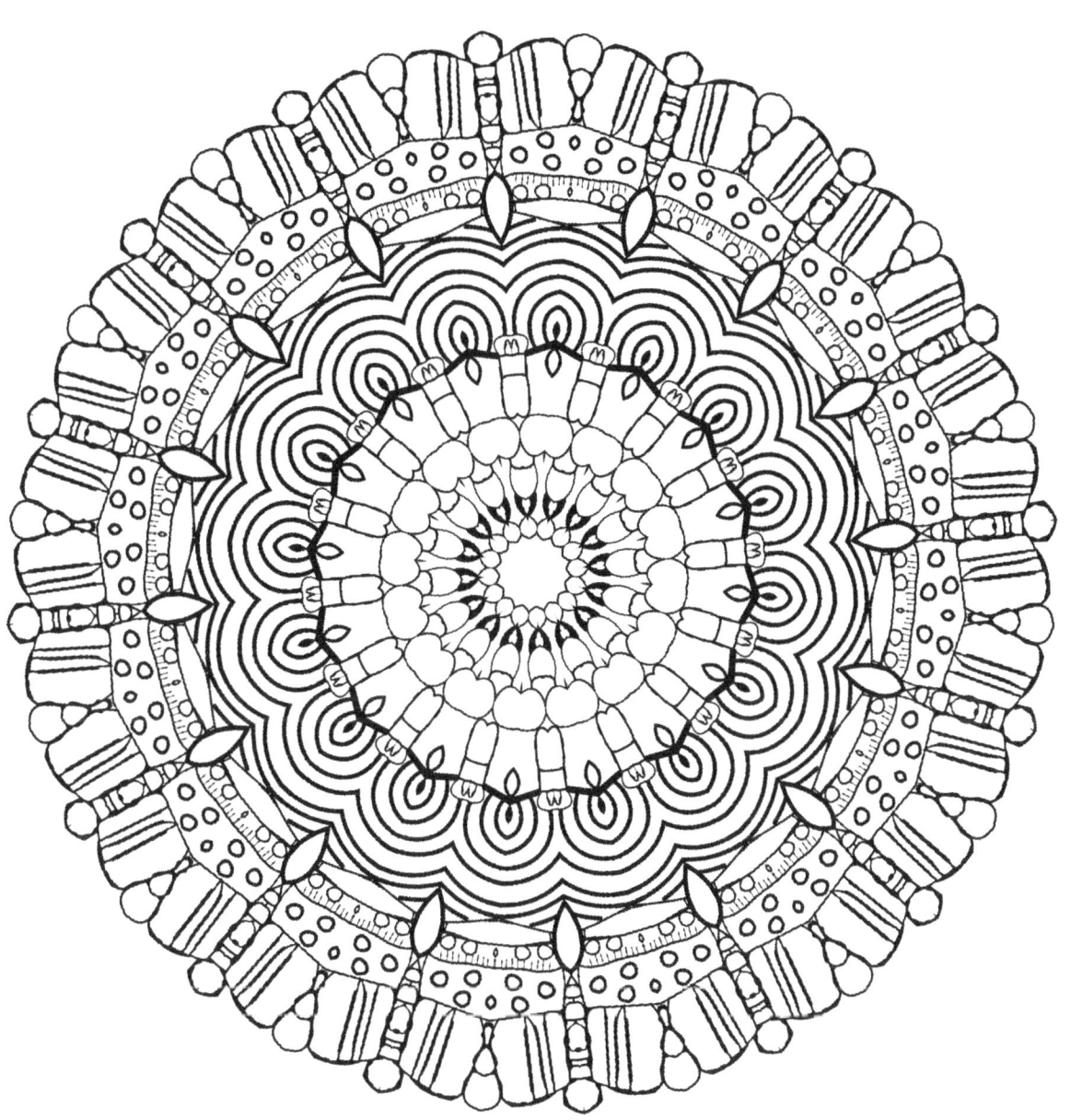

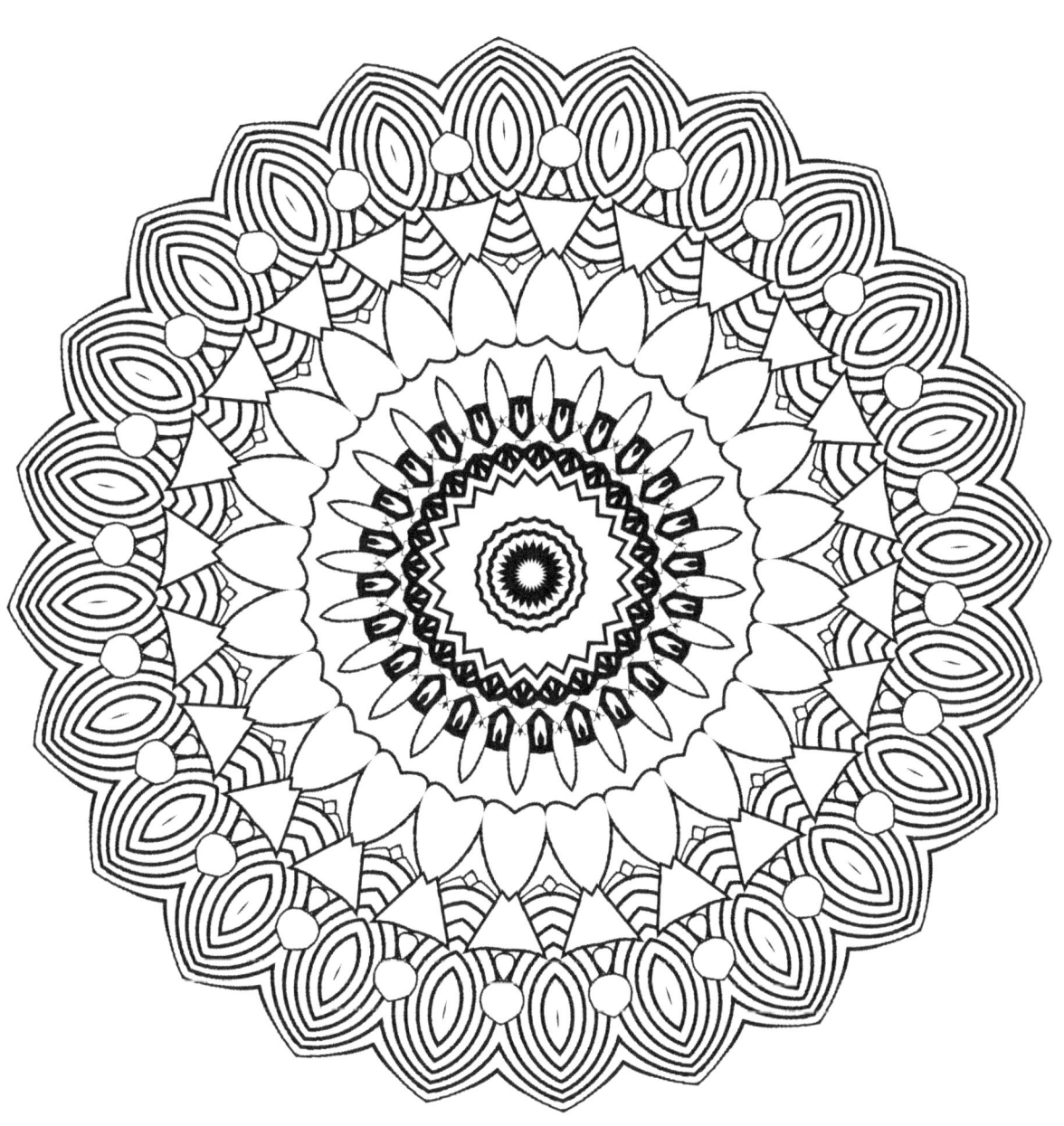

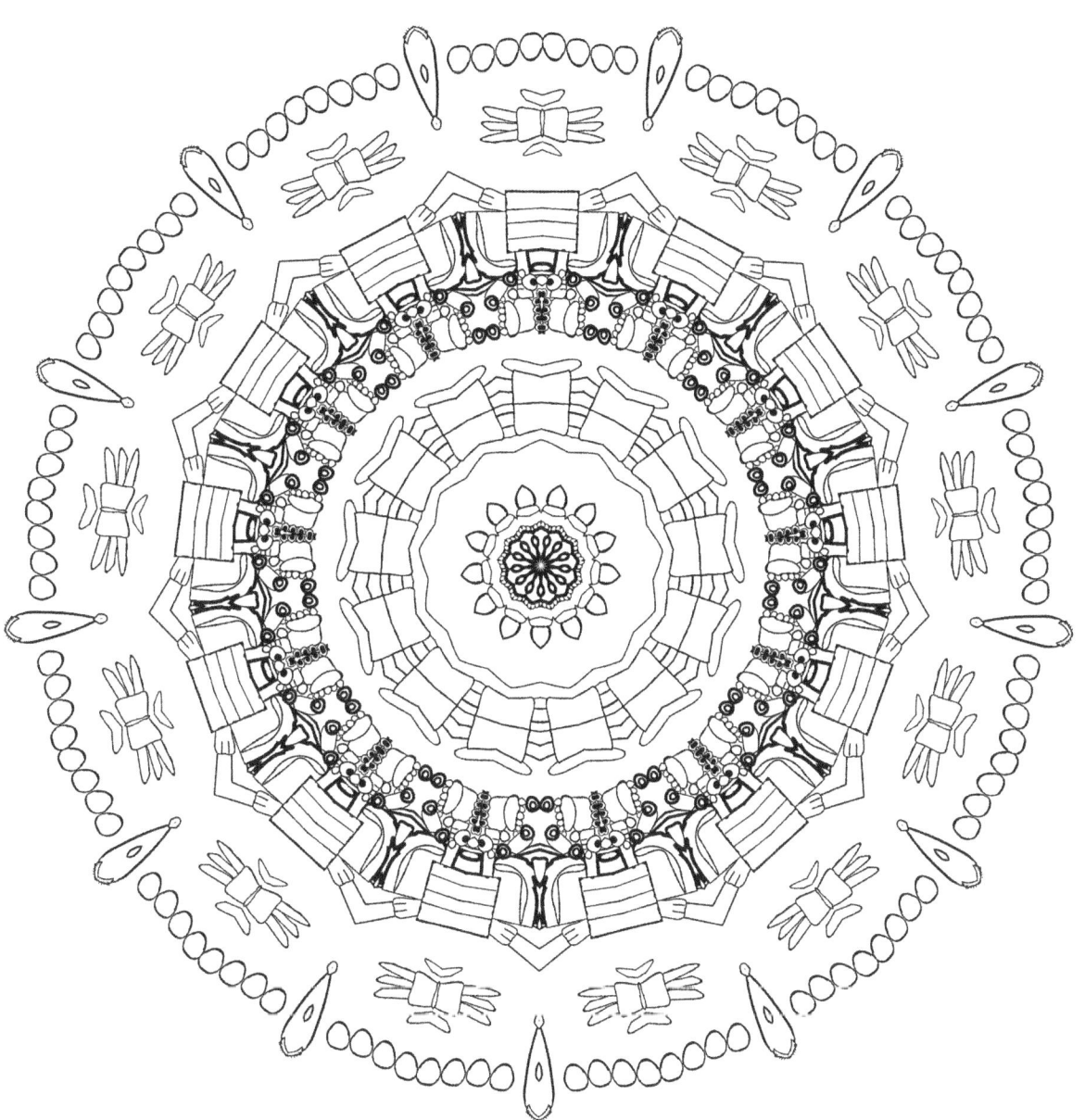

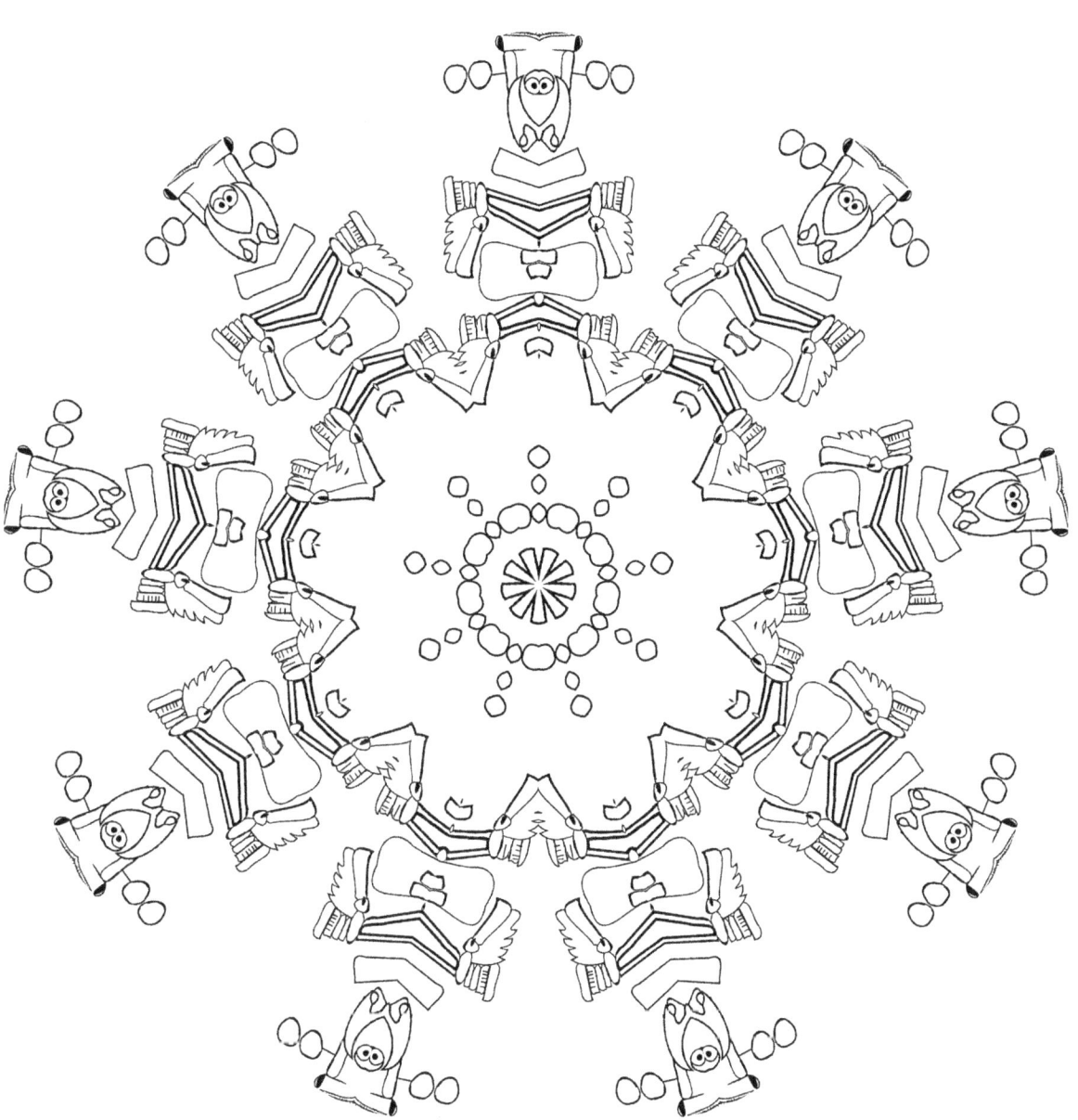

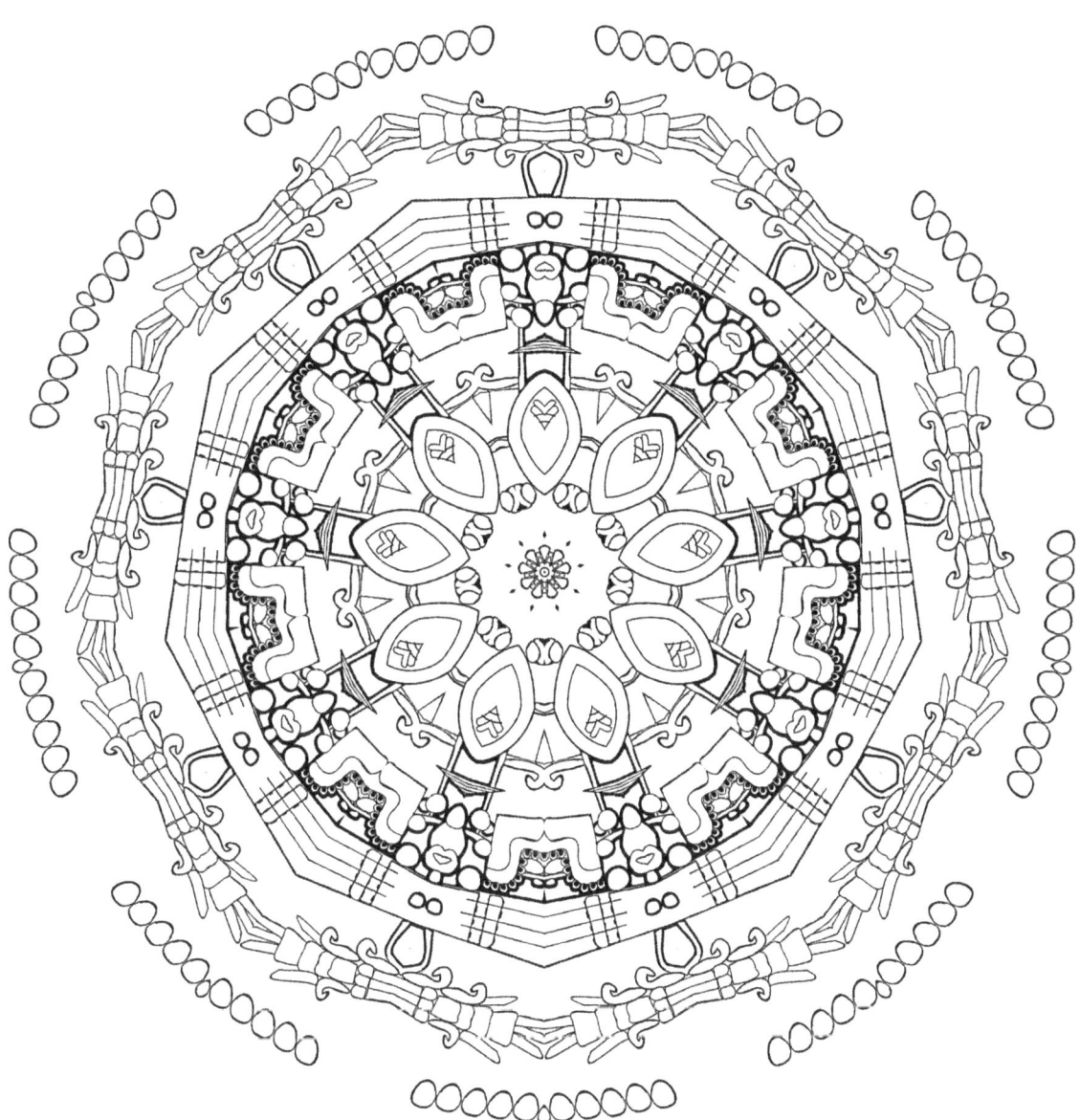

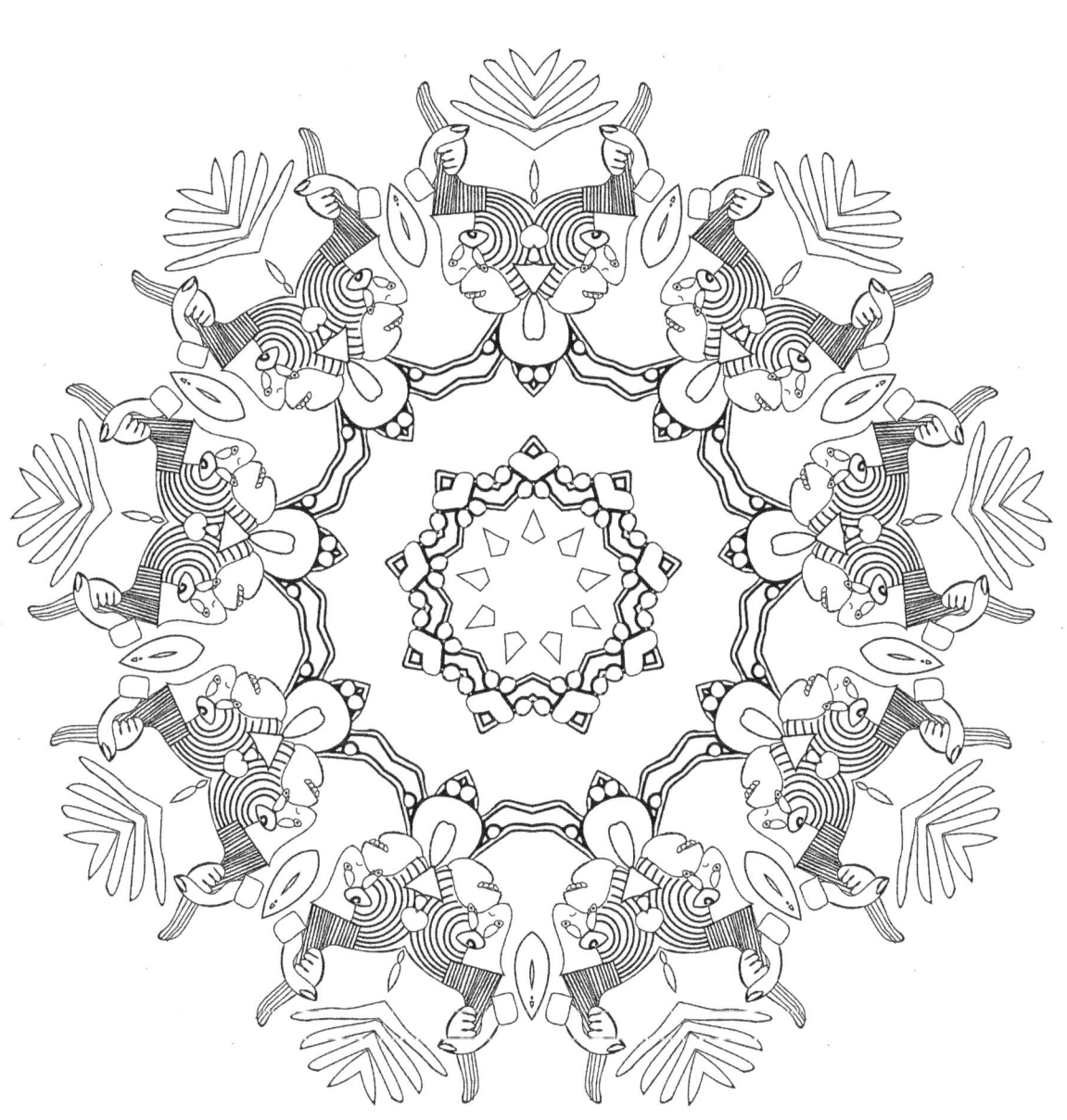

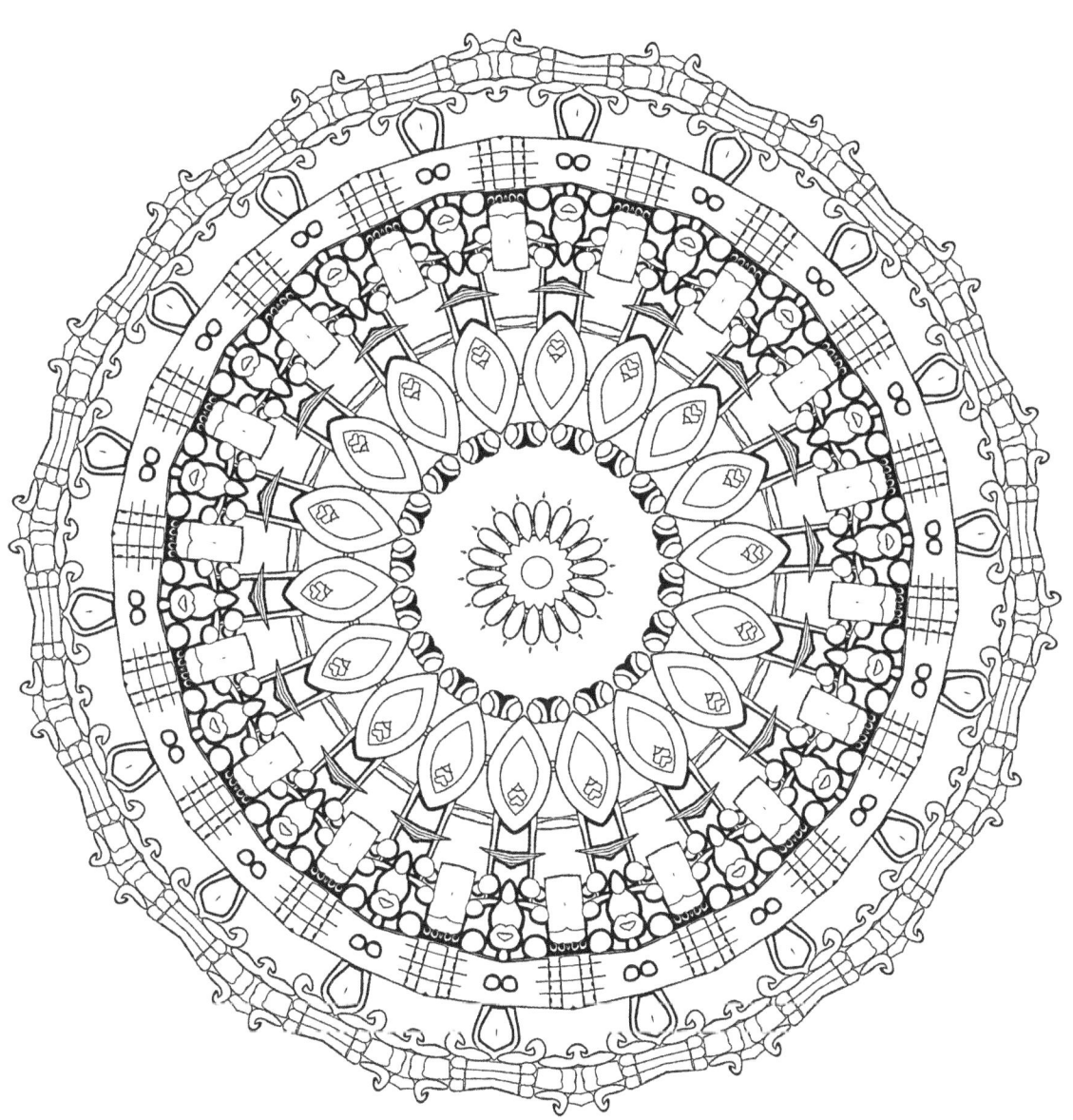

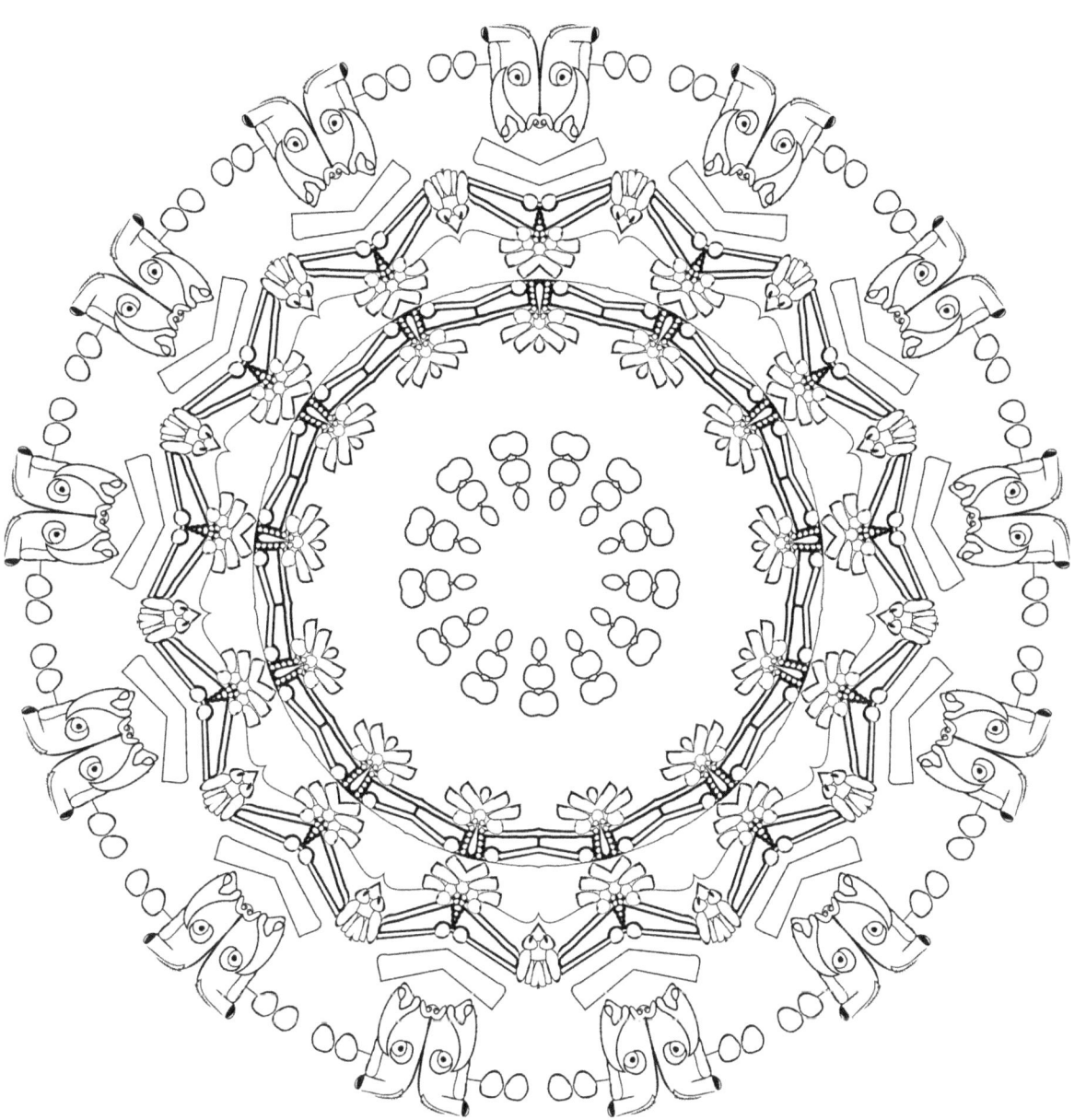

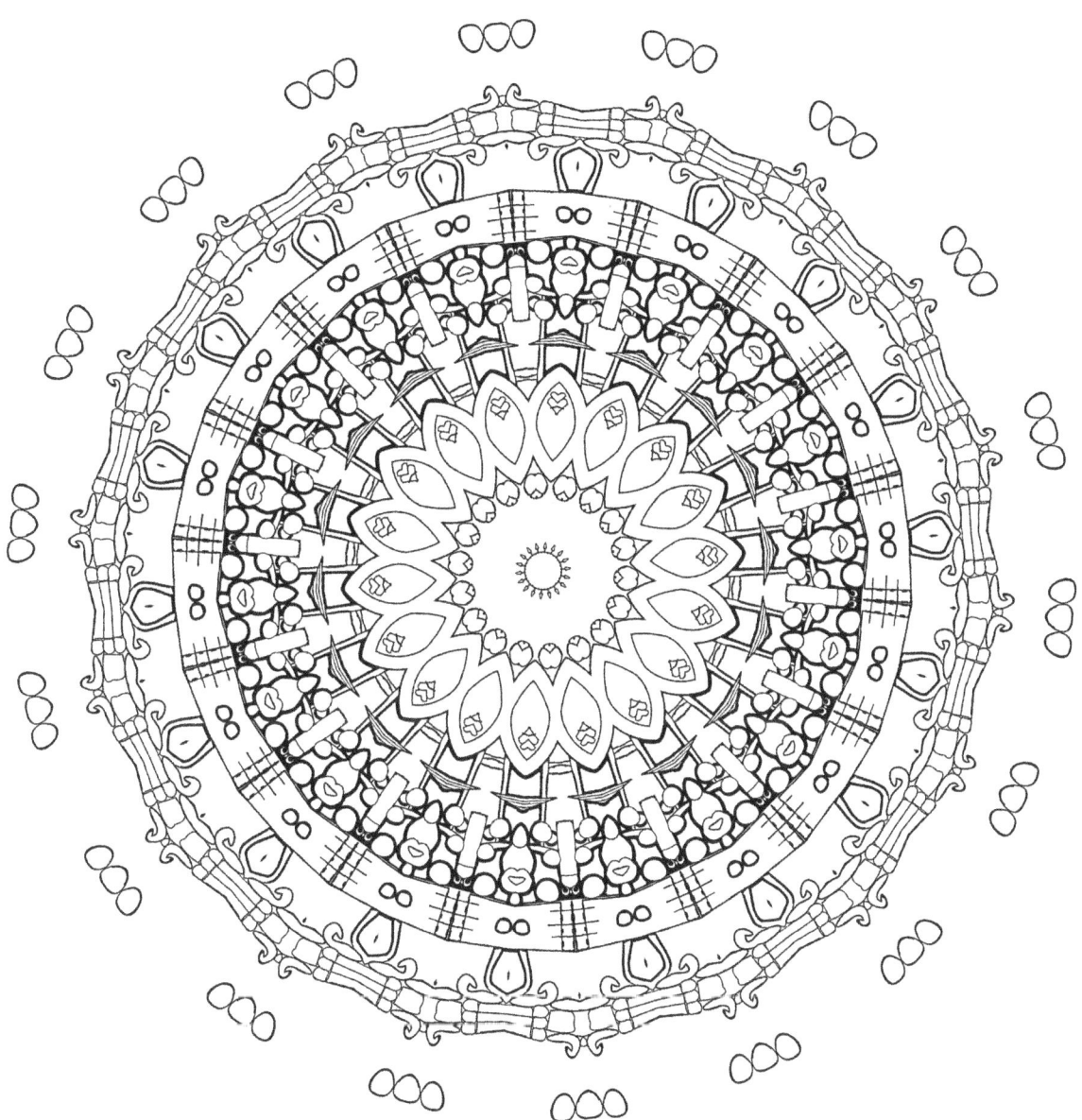

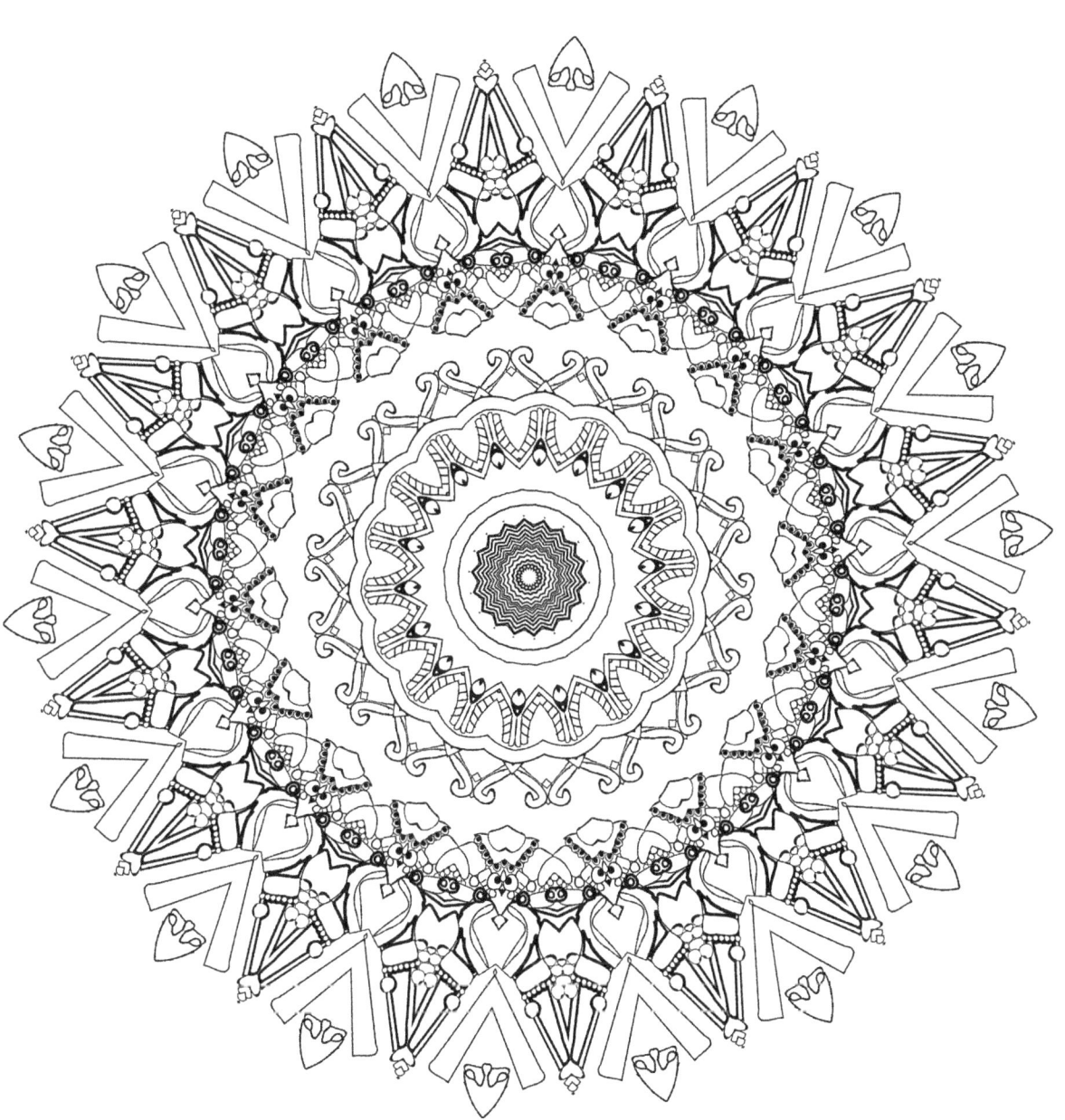

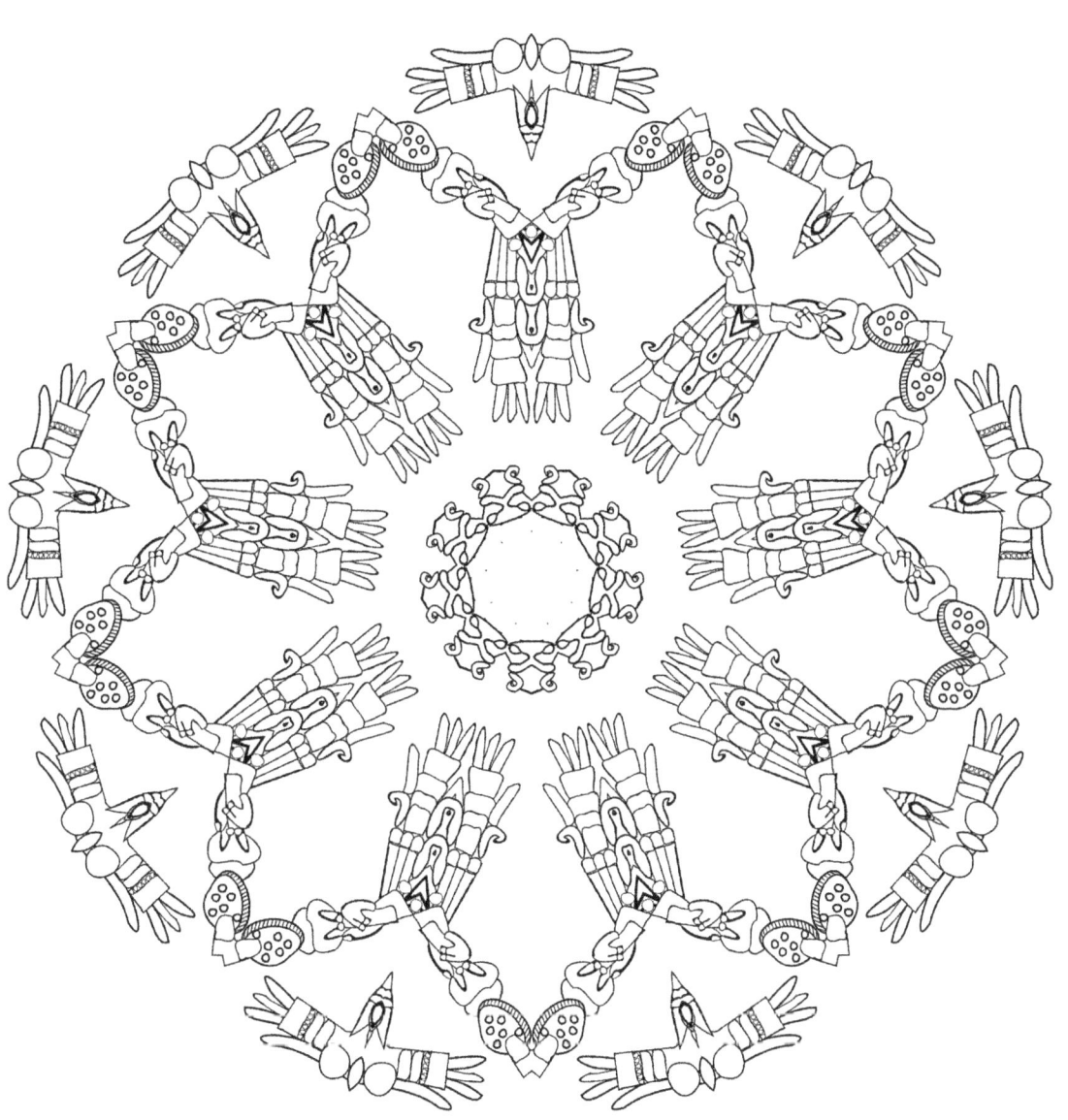

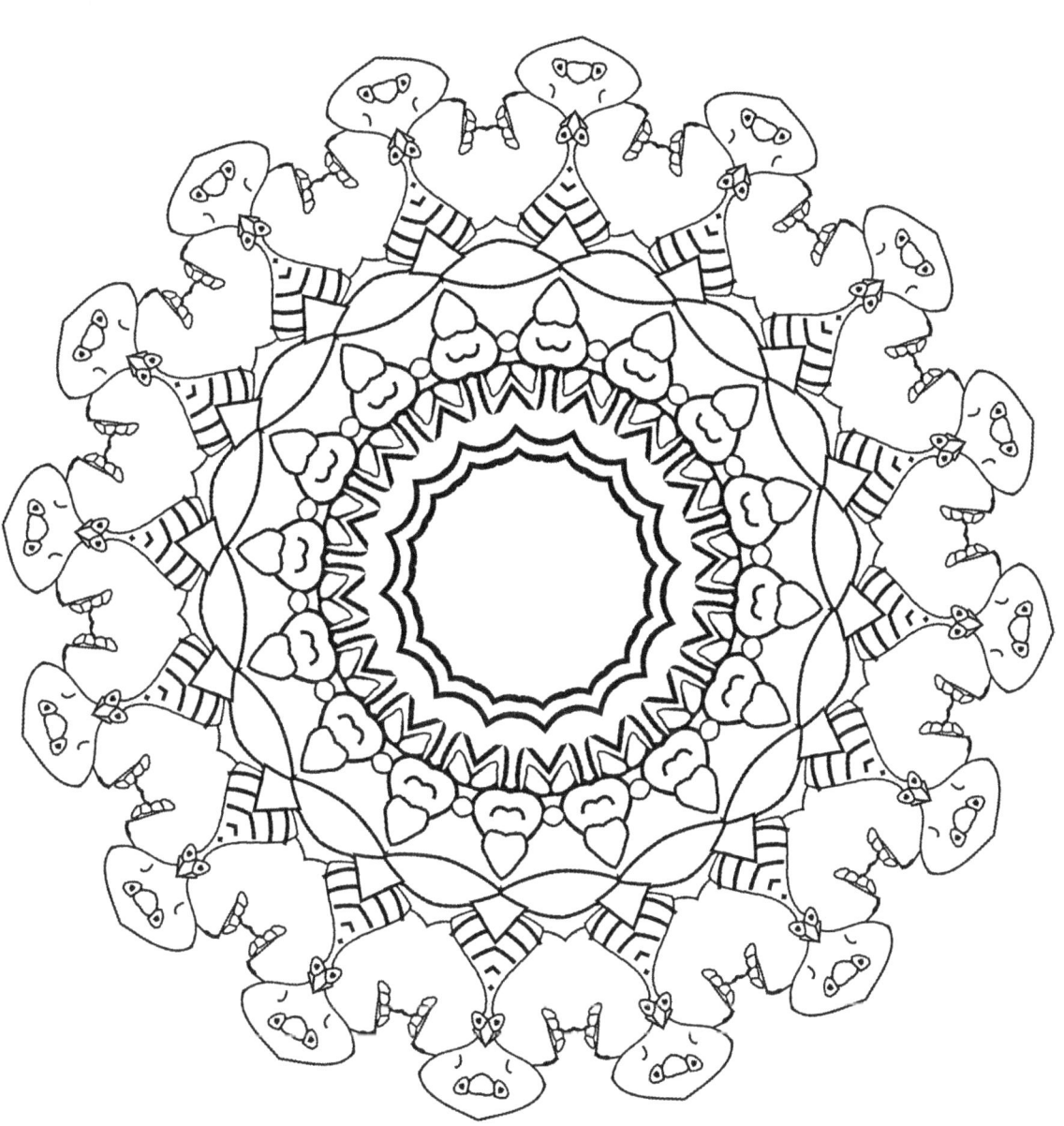

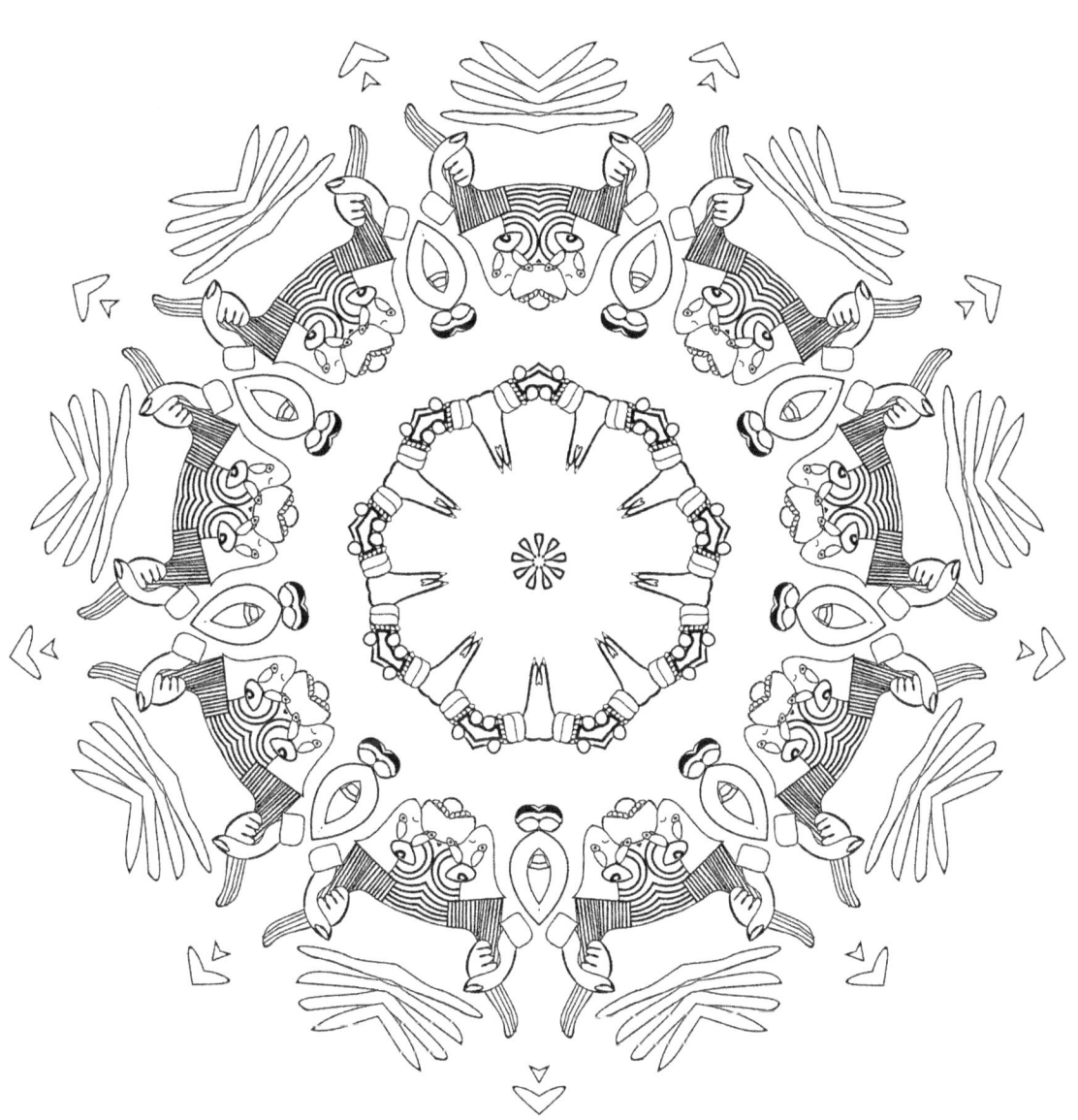

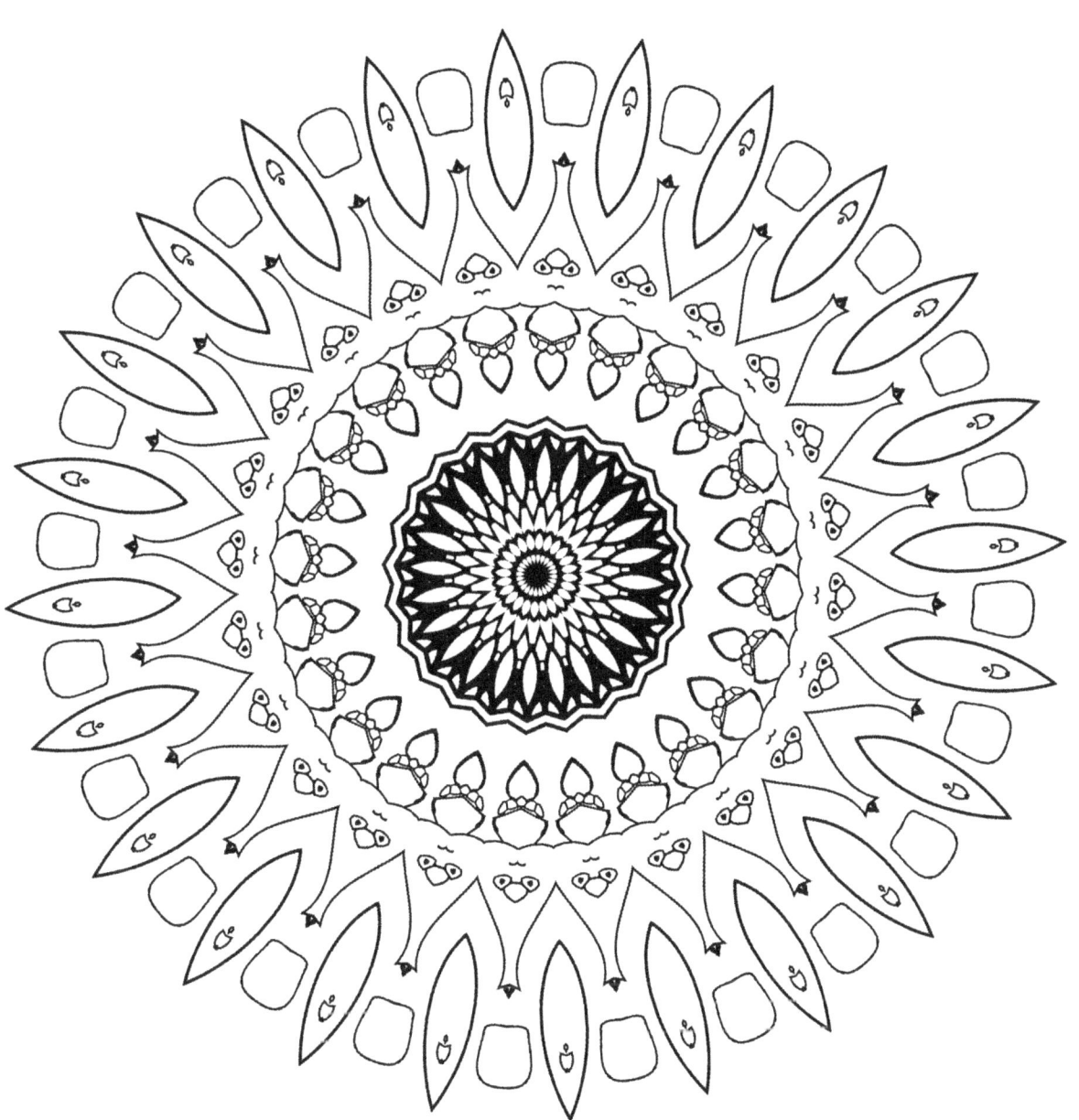

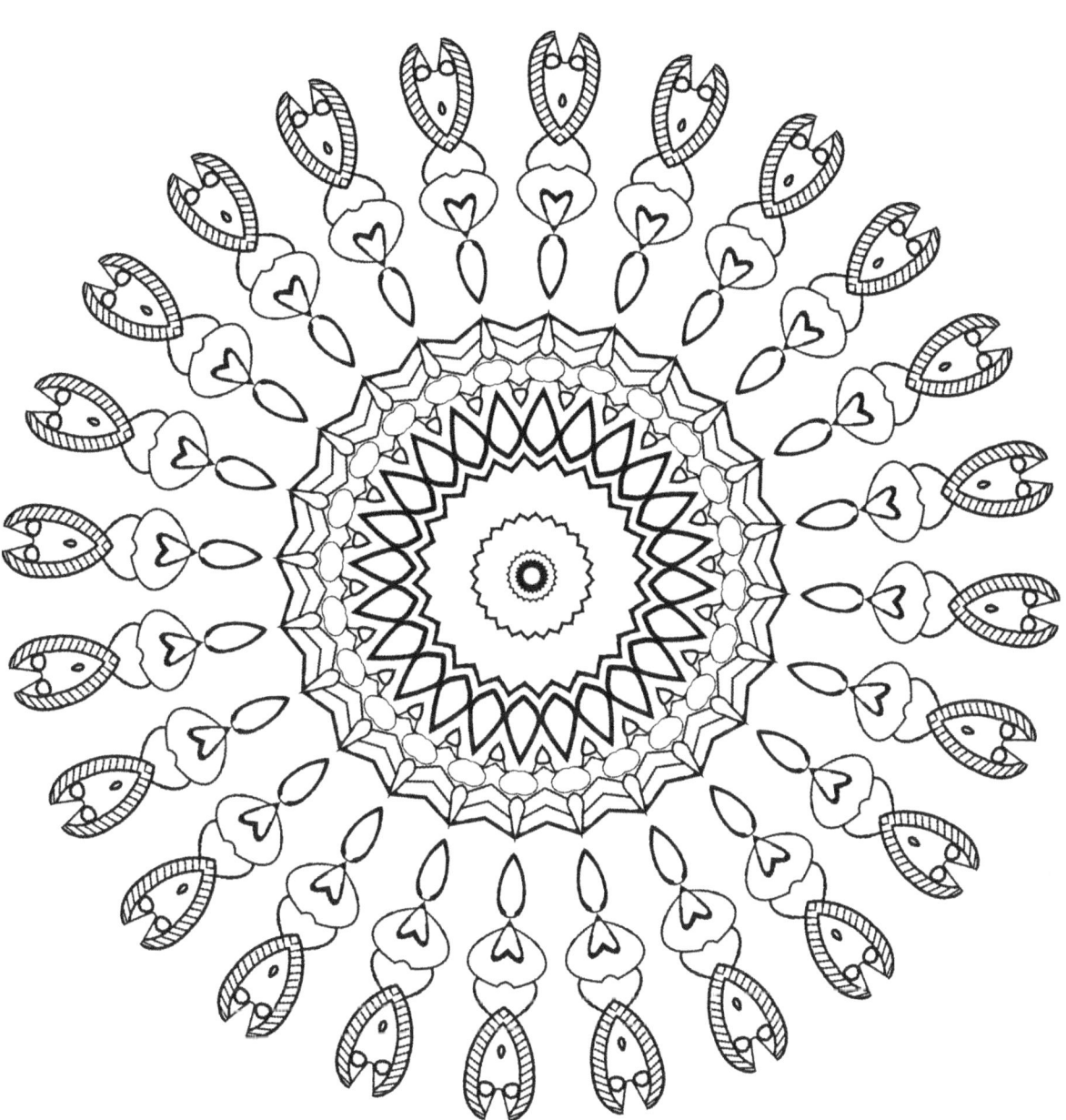

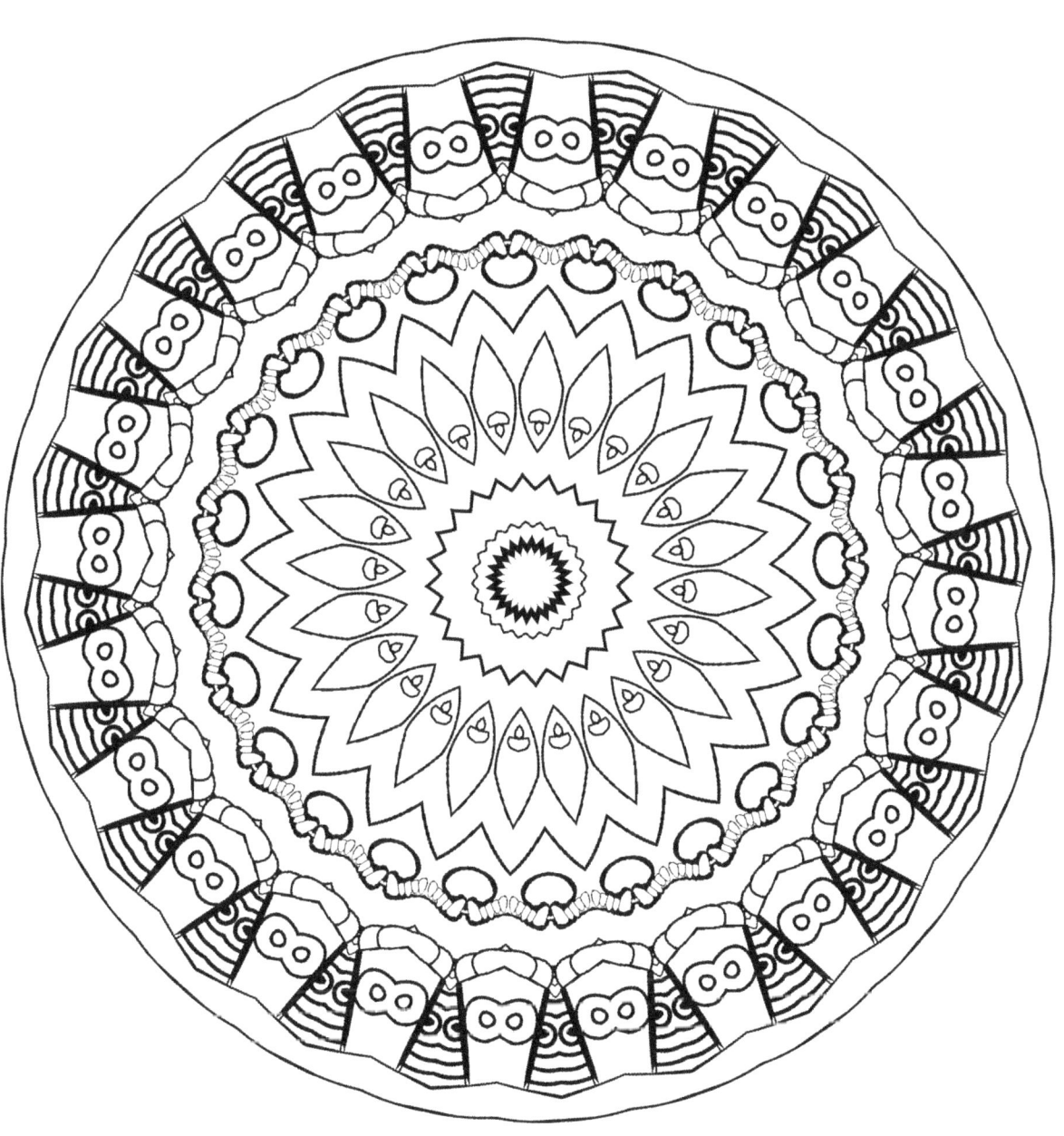

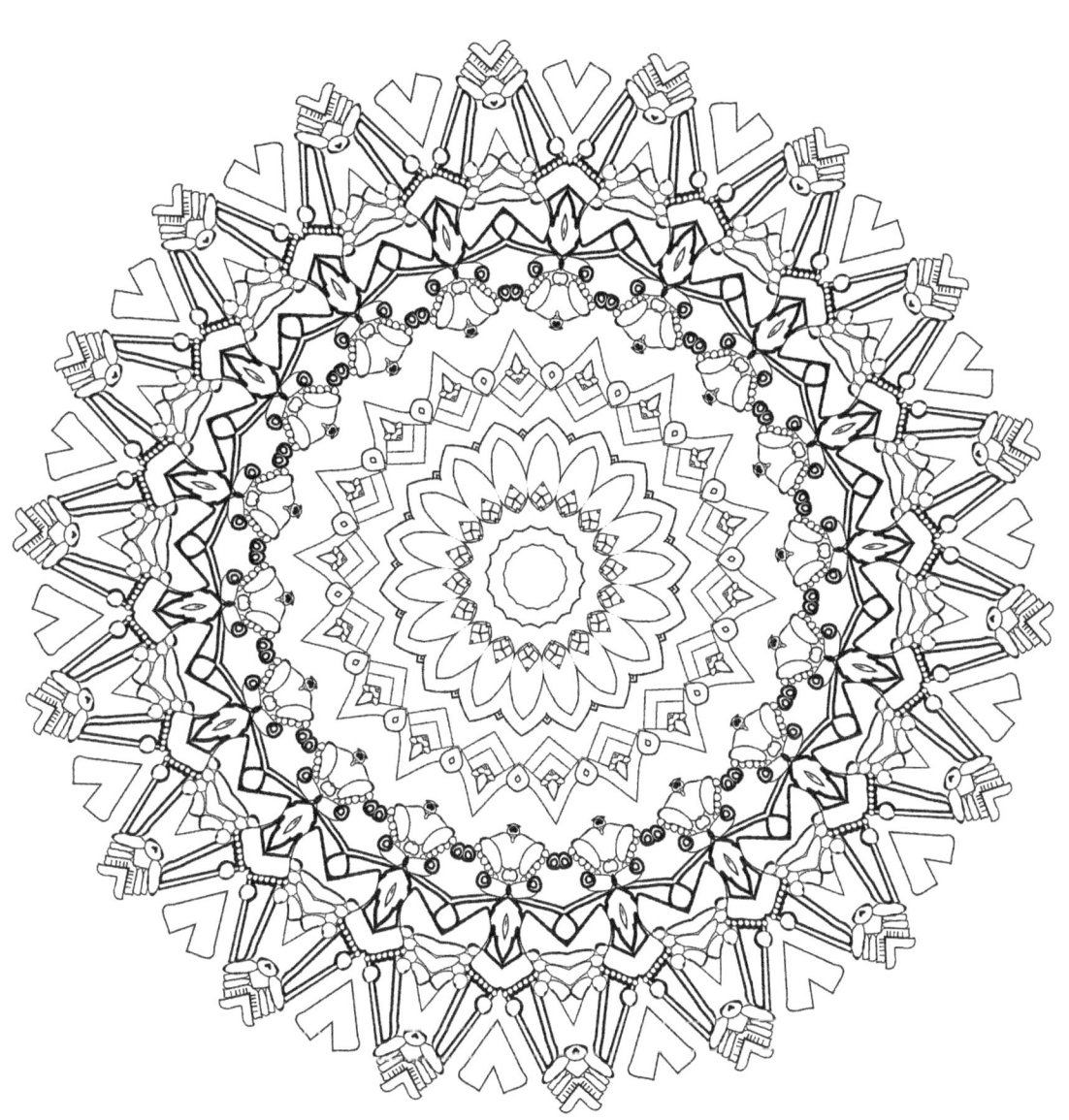

FINAL WORD

Thank you for your purchase!

More coloring books coming soon from Art Therapy Designs.

See our Facebook page for updates and giveaways!

Visit: www.facebook.com/ArtTherapyDesigns

www.ingramcontent.com/pod-product-compliance
Lightning Source LLC
Chambersburg PA
CBHW080714190526
45169CB00006B/2365